MUSKOKA

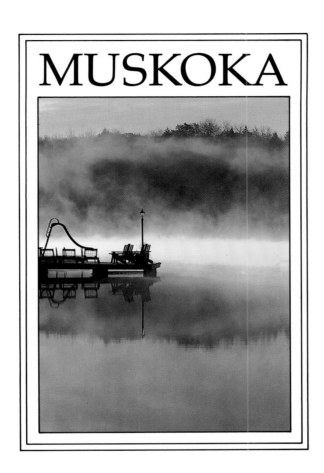

MUSKOKA

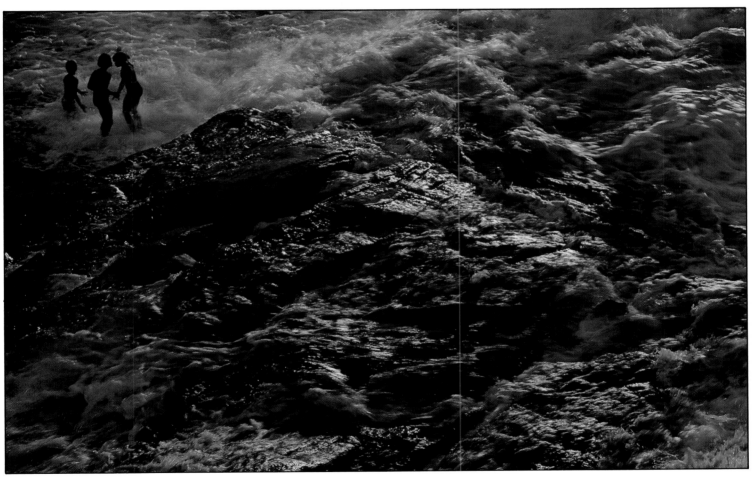

Photographs by John de Visser
Text by Judy Ross

THE BOSTON MILLS PRESS

Canadian Cataloguing in Publication Data

De Visser, John, 1930-
 Muskoka

ISBN 1-55046-004-8

 1. Muskoka (Ont.) — Description and travel — Views.
I. Ross, Judy, 1942- II. Title.

FC3095.M88D39 1989 971.3'1604'0222 C89-090133-3
F1059.M9D39 1989

Design by Gillian Stead
Edited by Noel Hudson
Typography by Justified Type, Guelph, Ontario
Printed by Khai Wah Litho, Singapore

Published by:
THE BOSTON MILLS PRESS
132 Main Street
Erin, Ontario N0B 1T0
(519) 833-2407
FAX (519) 833-2195

American Association
for State and Local History
Award of Merit

Winners of the
Heritage Canada
Communications Award

First Printing: June 1989
Second Printing: August 1989

The publisher wishes to acknowledge the financial assistance and encouragement of The Canada Council, the Ontario Arts Council and the Office of the Secretary of State.

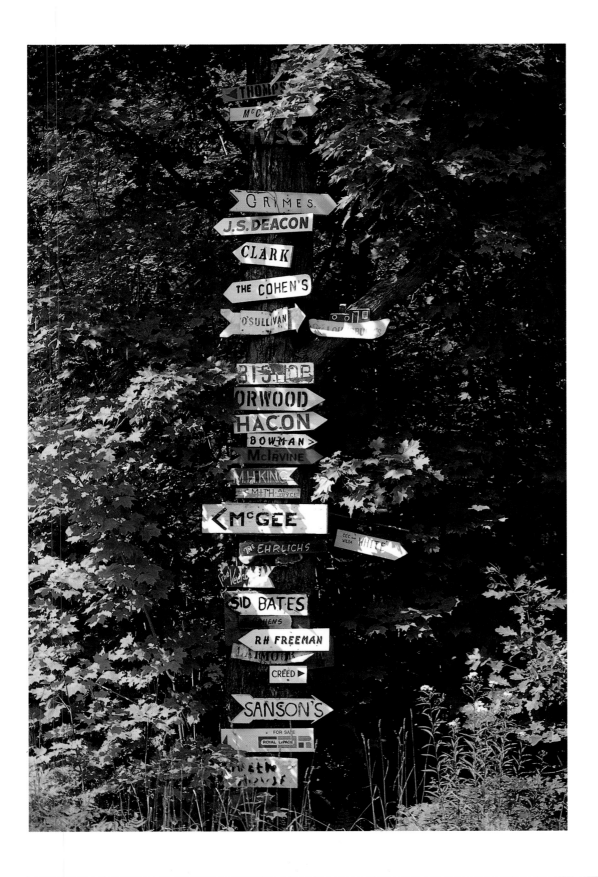

Contents

Walker's Point Road, Lake Muskoka

MUSKOKA

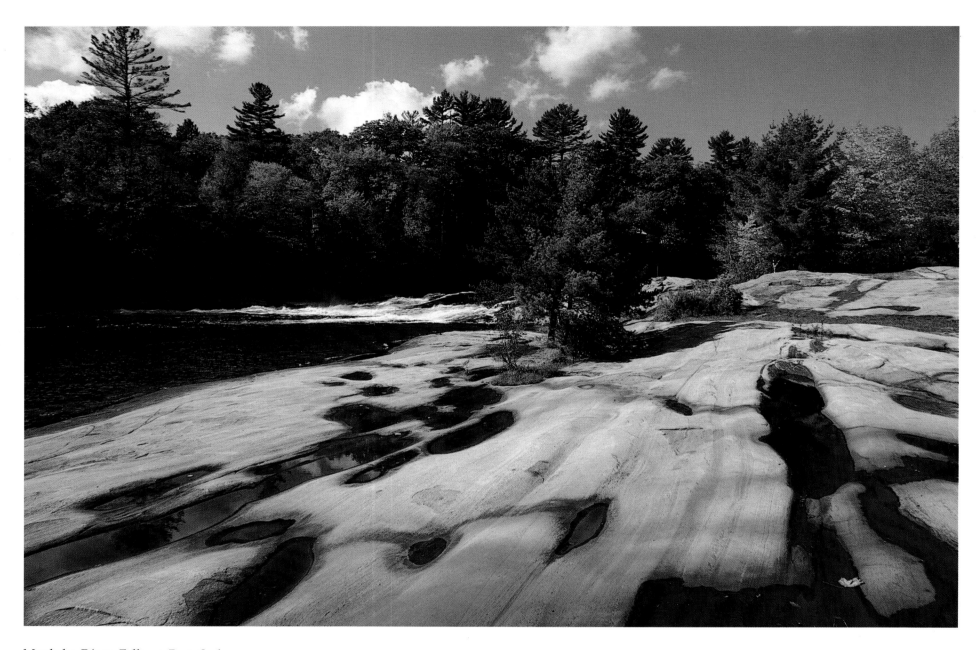

Muskoka River Falls at Port Sydney

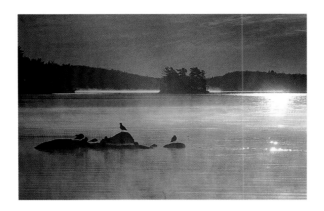

MUSKOKA — A Special Place

"The Muskoka interlude remained for me a sparkling, radiant memory, alight with the sunshine of unclouded skies, with the gleam of stars in a blue-black heaven."

The British writer Algernon Blackwood was writing of a visit to Muskoka at the turn of the century, but for those who know and love these lakes his memory could be the district's epigraph. Among the world's celebrated lakelands, its elemental beauty represents a kind of northern Canadian perfection: a land of sparkling lakes, thick green forests, tumbling waterfalls and dramatic rocky contours. On the vast map of Canada, it's merely a speck, roughly 650 kilometres square, bounded by Georgian Bay on the west and the Severn River on the south. To its north and east the boundaries blur into tracts of wilderness... "infinite riches in a little room."

Quintessentially Canadian in character, the area was discovered by a Frenchman, Samuel de Champlain, who travelled along its western boundaries in 1615, and later derived its name from an Indian chief known variously as Chief Yellowhead and "Mesqua Ukie," the latter being somehow twisted into "Muskoka."

But the unique character of Muskoka, the essence of its allure, has evolved not from the beauty of its landscape, but from the strength of emotions that tie people to this place. Roots here grow so deep and steadfast that, like migratory birds, Muskoka folk return from farflung corners of the earth. For cottagers, it's the memory of golden childhood summers and the very core of kindred existence. For people born and raised here, ancestors of the settlers who tried to tame this land, Muskoka is an integral part of their being. Among both "tourist" (as cottagers were called a century ago) and "settler" a determination prevails to guard the sanctity and conserve the beauty of this special place.

There have been changes. Muskoka has become a fashionable place in which to summer, a magnet for the glamour-seekers. The value of lakefront property has reached prices which in our grandparents' time would have bought half the district. But still, the air is as clear as a crystal spring, the landscape remains largely unchanged, and the power of the place — its gift of solace — is undiminished.

Whiteside Road, Lake Muskoka

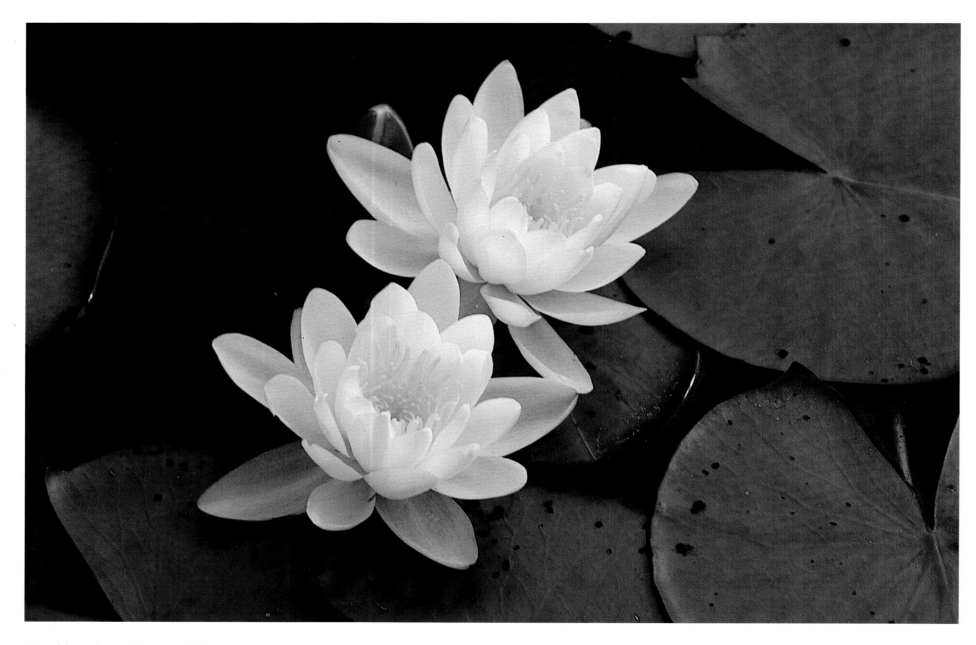

Waterlilies along Highway 118

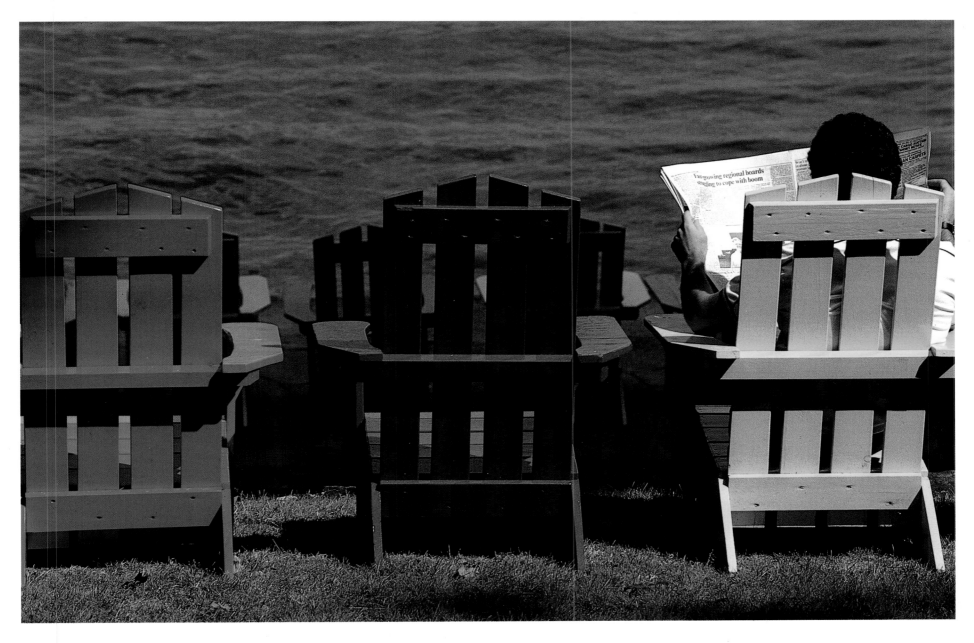

Muskoka chairs, Clevelands House, Lake Rosseau

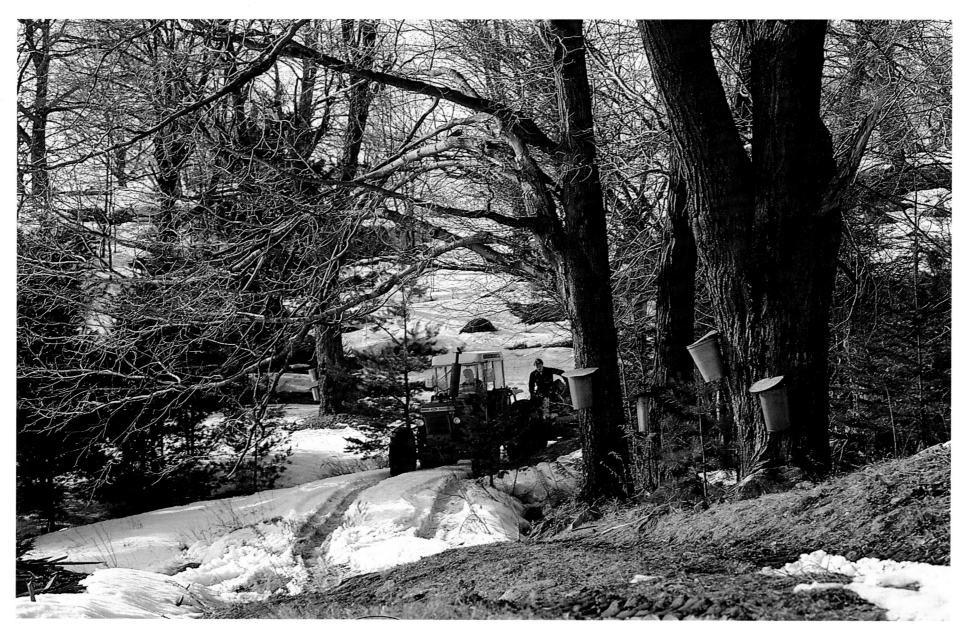

Maple Sugar Bush north of Beaumaris

EARLY SPRING

April 11th. The woods are quiet and musty. Stubborn remnants of crusted snow still cling in shaded nooks, but in the clearing the sun's rays feel summer hot. Underfoot the spongy ground smells of mildewed leaves. All is silent, except the chorus of birds celebrating the new season. From Lookout Point the bay lies in peaceful stillness and on the far shore budless trees weave ribbons of mauve between the dark green pines.

Wildlife signs are everywhere. Fresh deer tracks, gnawed branches discarded by a beaver, a loon's nest near the water's edge, and scuttling through the leaves ahead a baby chipmunk scrambles to the safety of his underground home.

The lake is as still as a millpond. Chunks of black ice float in slowly moving circles like giant jigsaw pieces, while closer to shore the glassy water mirrors a boathouse gleaming with white trim. This year the ice is going out gently. It's not always so, as many boathouse and dock owners know. Some years the crushing force of ice upheaves docks and shoves boathouses from their cribs. And every year the ice goes out on a different date. Cecil Fraser of Fraser's Home Hardware in Port Carling has been keeping a record that

dates back to 1900. By his account the earliest date for the ice clearing on the lakes is March 26 (1946) and the latest, May 7 (1926).

On this April 11th the ice on Lake Joseph still lies in pockmarked masses, but the sun is shining, it's unnaturally hot, and by nightfall the ice will be gone. It's a time for bathing suits and stretching out on the winter damp dock. Two 14-year-old girls, baring their still white bodies, are lulled by the heat of the sun into discussing the earliest recorded date for a swim in the lake. Propelled by bravado one of the young bodies dives in, and pushing away the floating ice she swims to a raft about 20, very rapid, freestyle strokes away. Gasping, she pulls herself up on the raft, and like a jumping jack she bounds up and down trying to shake off the cold. Her friend follows and there are two jumping jacks, giggling and pleading for someone to rescue them.

Soon after, another record, the first boat on the lake. Dad, after rummaging beneath an old shed to dig out a canoe, paddles to the rescue of the raft-marooned young girls.

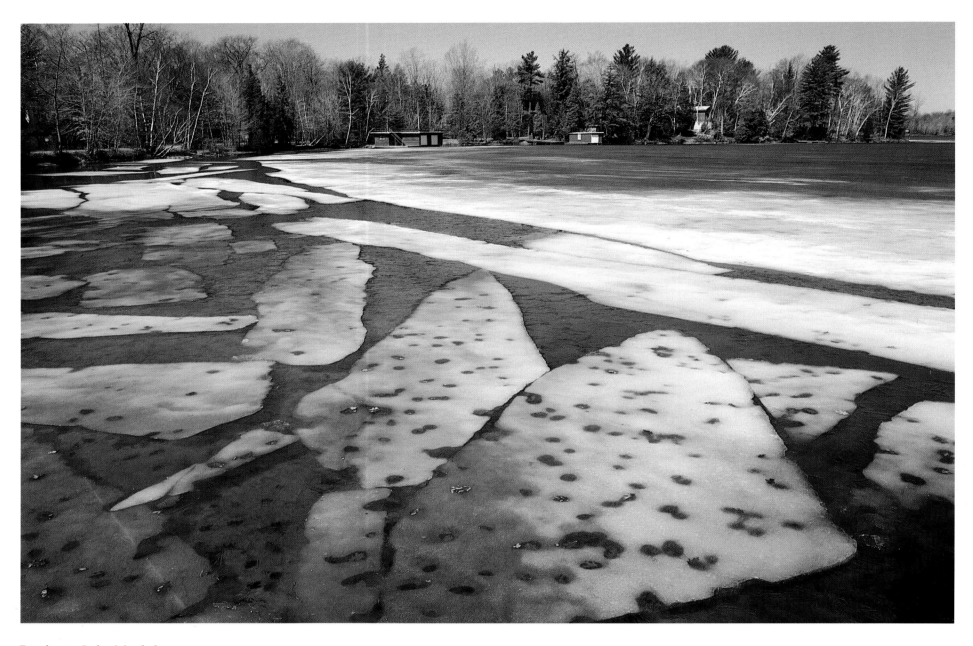

Break-up, Lake Muskoka

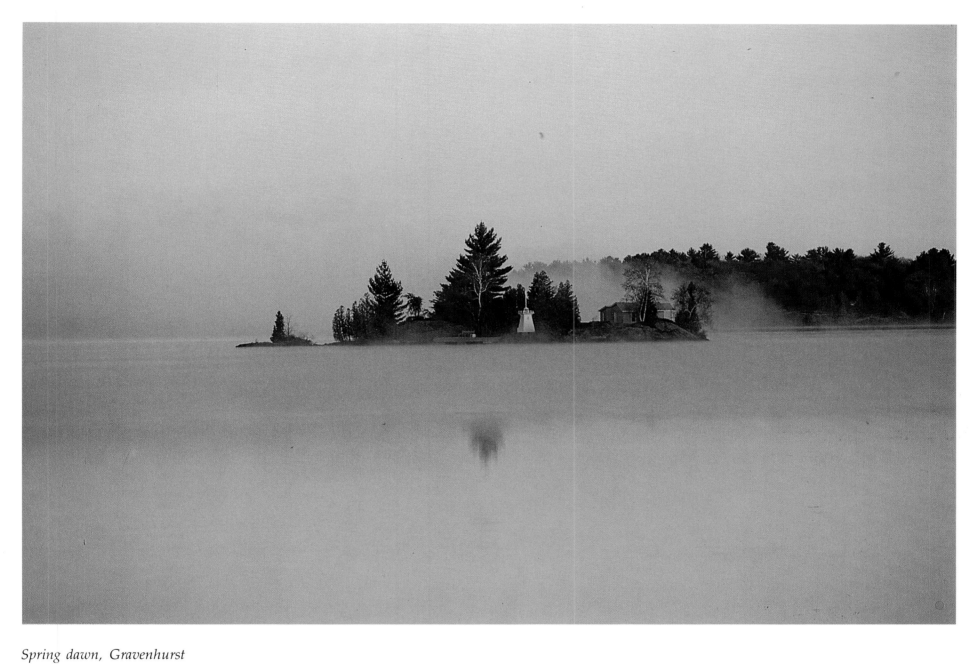

Spring dawn, Gravenhurst

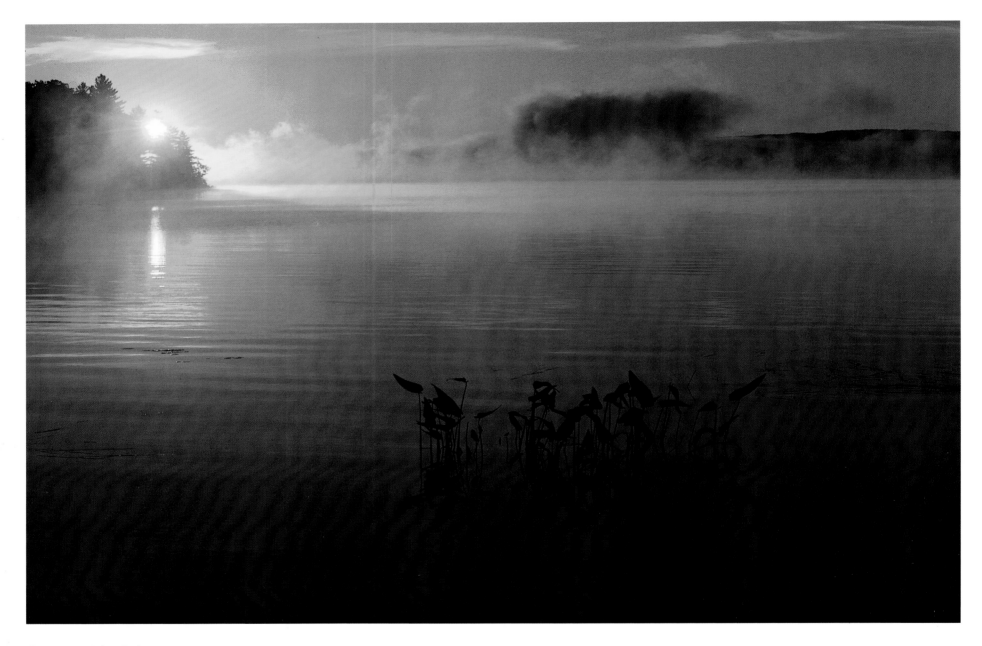

Dawn at Fairy Lake

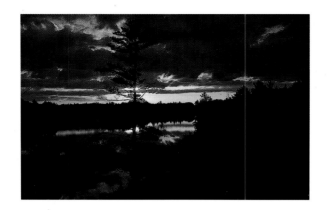

THE FIRST TOURISTS ON THE LAKE

August 5, 1861. Three young men, barely out of their teens, arrive at Union Station in Toronto to board the Toronto, Simcoe & Muskoka Junction Railway for the first leg of their journey to the Muskoka lakes. In 1861 Muskoka is Indian territory, known to fur traders, surveyors and the first wave of settlers who have come because of the free land grants. But for most people living in settled areas to the south, it's still a vast unknown wilderness. But these intrepid young men, seeking adventure for their one-week holiday, have decided to repeat their trip of last summer, when two of them "walked" to Muskoka.

The two, James Bain Jr. and John Campbell, work at the publishing firm of John's father, James Campbell & Son, and joining them is a friend called Crombie and his dog. The group board the train, taking with them homemade knapsacks full of food, a gun, powder and shot flasks, fishing gear and a box for botanical specimens. Near Barrie (the end of the line at the time) they leave the train at Belle Ewart on Lake Simcoe and travel by the steamer *Emily May* through lakes Simcoe and Couchiching to Orillia. By then it is almost nightfall, so they spend the night in a hotel.

Early the next morning they rent a rowboat and, taking turns at the oars, row up Lake Couchiching to Washago. Even though it's dark when they reach Washago, they continue the journey, walking a few miles through the woods to Severn Bridge, where they find shelter and the convivial company of Mr. and Mrs. Dillon, proprietors of the Severn Bridge Hotel.

After a good night's sleep they set off again, this time over the newly built Muskoka road. The previous winter the government had completed the colonization road from Washago to the south falls on the Muskoka River, three miles south of the present site of Bracebridge. Although little more than a stretch of mud, it eased the way for settlers searching out their land grants.

Swatting the black-flies and mosquitoes with leafy branches, the three men (with Crombie's dog in tow) trudge 12 miles through the dense bush. The first sign of life, a log hut known as McCabe's tavern (located where the gates to Gravenhurst now stand), is a welcome sight. Stooping to enter the low door they are greeted by Michael McCabe and his boisterous wife, Mother McCabe. Writing in his journal that night James Bain tells of being thirsty and Mother McCabe mixing them a drink which they christen "stirabout." It is "a quart of water mixed with a cupful of vinegar and another of molasses..."

From here, well fortified by "stirabout," they set off again for a two-mile walk to the nearest point on Muskoka Bay, now the Gravenhurst public wharf. There, on a sandy beach, deserted except for a couple of Indian wigwams, they find a leaky scow pulled up on the shore. The scow has only one paddle, so they cut a pole out of the bush and then set off to paddle, pole, and bail their way out to the Narrows and back, stopping to collect botanical specimens from the shore along the way. In so doing this trio of young men and Crombie's dog become the first known tourists to paddle on Lake Muskoka.

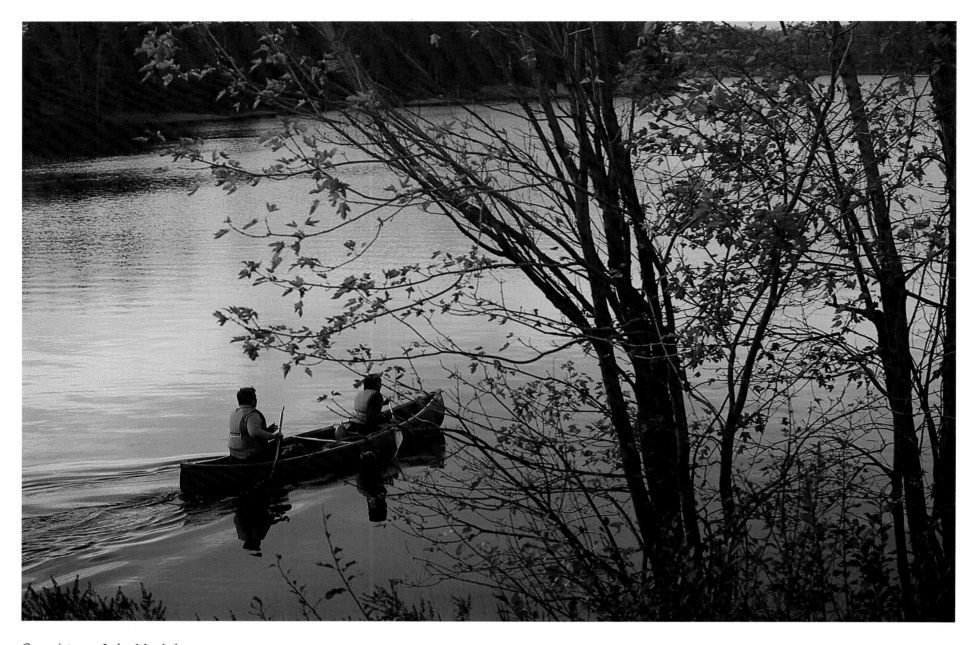

Canoeists on Lake Muskoka

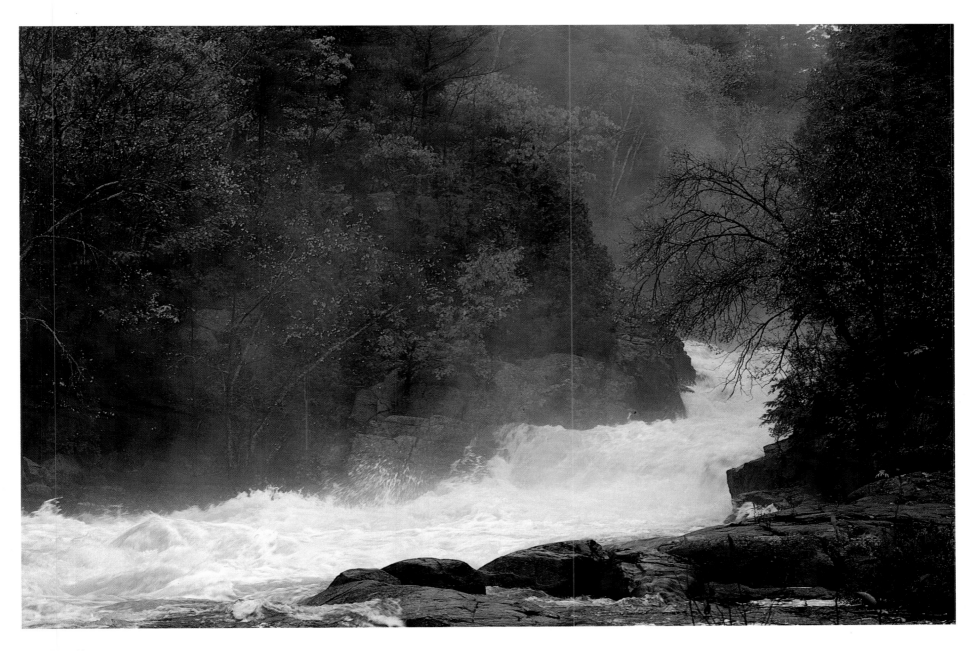

South Falls

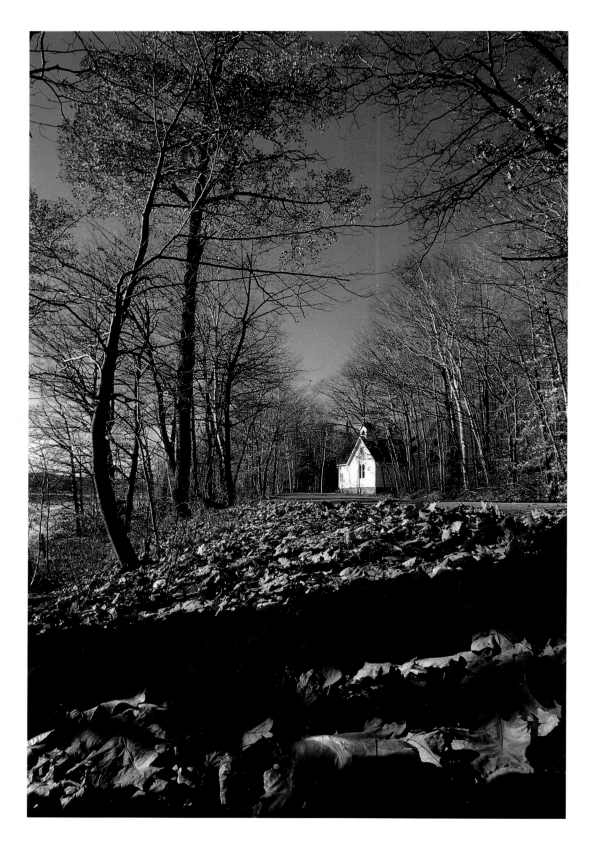

St. John's Anglican Church, Lake of Bays

A SETTLER'S TALE

December 26, 1944. The tiny St. John's Anglican Church is packed with family and friends who have set aside festive celebrations to attend the funeral service of Boyce Henry Cunnington. He died on Christmas Eve at the age of 90, leaving his legacy in the peninsula that still bears his name on Lake of Bays. As the minister concluded the service he offered words of condolence lifted from the epithet of the famous London architect Sir Christopher Wren: "If you would see his monument, look about you."

Looking about from his gravesite next to the church, it seems little has changed. The clapboard home with its fanciful gingerbread trim still sits on the sloping lawn of the tranquil bay just as it did in 1890, when Boyce Cunnington first opened it as a lodge for tourists. Now, as then, the bay is quiet enough that a family of mallard ducks cruise confidently along the shoreline in the early morning and at twilight a pair of loons cry out in the still air. There's a feeling of timelessness here, enhanced by the soft green hills, deserted sandy shoreline and clear blue water of the lake.

Boyce Cunnington's story is one of fortitude, not unlike many of the settlers who came to Muskoka, overcame hardships, and stayed to develop the area. He was born in England on June 16, 1854, and six months later his father died. His mother, unable to care for her infant son, gave him to a working orphanage, and in 1868, when only 14 years old, young Boyce rejected life as a "Home Boy," as these orphans were called, and left for Canada on a sea voyage that was so wretched he vowed to never return.

After working as a farmhand around Barrie for several years, he made his way north, and in 1890 he bought property and began a tourist resort on Lake of Bays. Over the years the lodge expanded and Boyce married twice, producing a total of 12 children. He became postmaster, drove the mail stage, became Justice of the Peace, secretary of the local Anglican Church, and president of the Huntsville and Lake of Bays Telephone Company. His presence was well felt in the area and old photographs still suggest something of his pride and stature.

On the map Port Cunnington looks like a bloated peninsula extending into Lake of Bays and almost touching the backside of Bigwin Island. All down its spine Muskoka Road 22 twists and bends through thick woods, dipping down to the lake in places where ancient willows bend over the shallow water. Just before it reaches the tip of the peninsula, there's a clearing on a lovely sweep of bay where the lodge still stands, painted in soft blue with prim white gingerbread trim. Inside the lodge, now owned by the Stafford family, old sepia photographs of the Cunnington family and early guests line the library walls. And Audrey Loader, the manager, is there to carry on the legacy. She's Boyce Cunnington's granddaughter.

"I remember him well," Audrey recalls. "We often came to visit grandfather. He was an imposing man with a big white beard. I remember I used to worry about having to give him a kiss. I hated kissing him because of the beard — and he smoked a pipe. But then he always gave us a chocolate

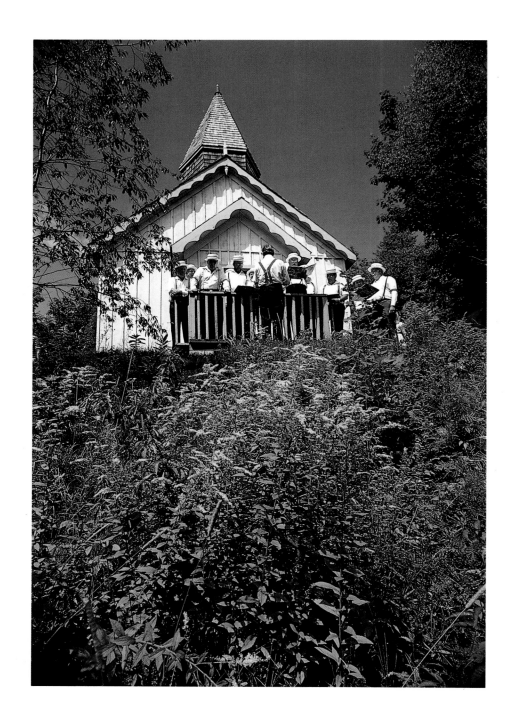

Glee Club, Muskoka Pioneer Village, Huntsville

bar after we kissed him, a Neilson Crispy Crunch. To this day I think of grandfather when I eat a Crispy Crunch bar."

As the sun dips beyond a hill across the lake, an autumn chill fills the air for the first time. The group down by the lake are pulling sweaters over their heads as they gather on the lawn outside the boathouse. Earlier that day a guest arrived just to look at the place. She had stayed at the lodge in the thirties and wondered what she would find on a late summer day in 1987. According to Audrey Loader she was delighted to find so little change. Maybe Boyce Cunnington would be too.

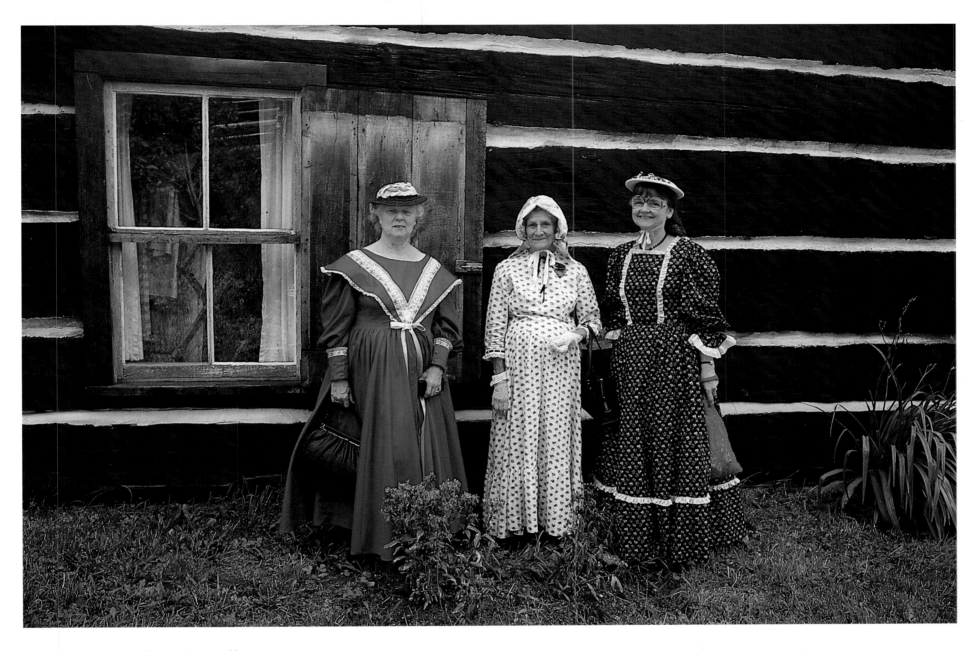

Muskoka Pioneer Village, Huntsville

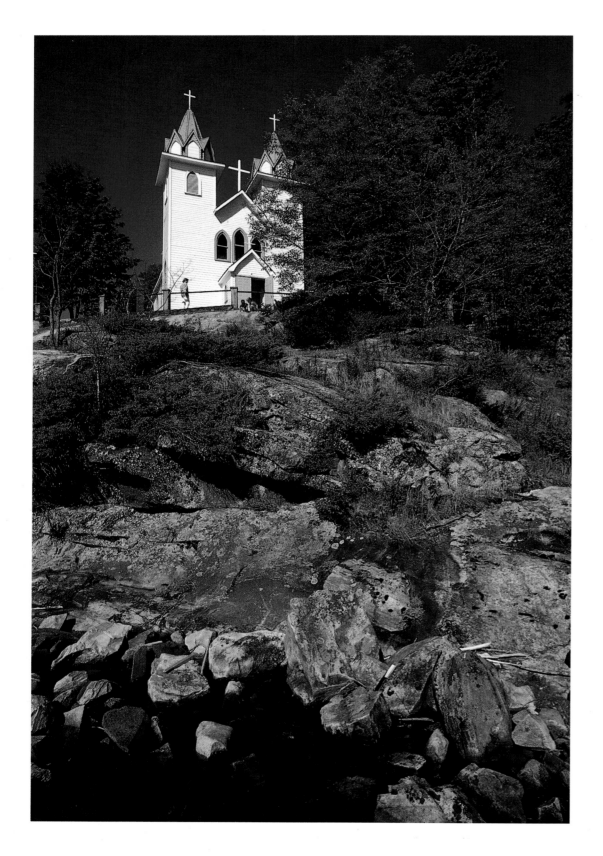

Morinus Church, Lake Rosseau

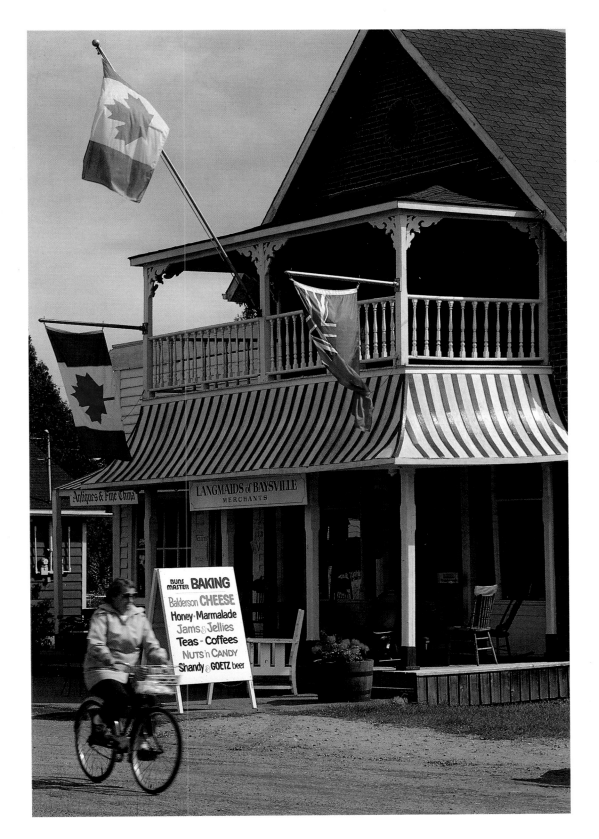

Langmaids of Baysville

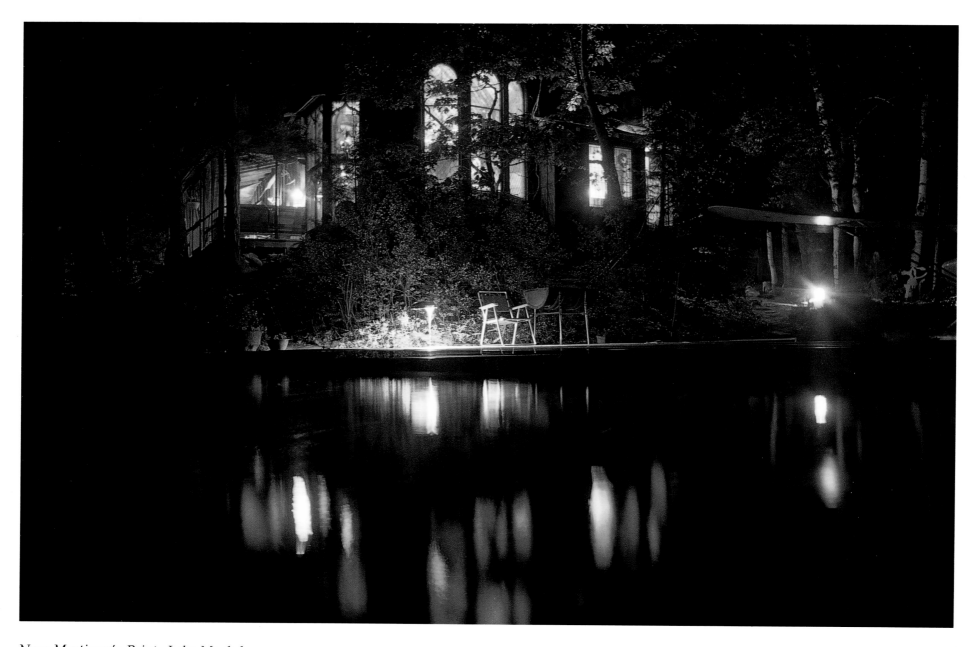

Near Mortimer's Point, Lake Muskoka

QUEEN VICTORIA'S BIRTHDAY

May 24, 1950. "Oh, the twenty-fourth of May is the Queen's birthday. If we don't get a holiday we'll all run away." The children chanting in the back seat of the car travelling north to Muskoka have little notion of who Queen Victoria is or why they should be entitled to a holiday because it's her birthday. But it's one of those enduring Canadian traditions of particular significance to cottage owners because it's the first long weekend after Easter and usually the first presummer trip to the cottage. It's a time when the cottage is opened up for the coming season, and for the children, it's an enchanting time when fireworks explode all around the lake to celebrate the birthday of the long-dead queen.

In the trunk of the car, along with cartons of food, baskets of clean bedding, old mattress covers, new life preservers, and a bag full of mousetraps and household cleaning supplies, is a large red carton marked EXPLOSIVES on the lid and containing an assortment of firecrackers made by the T.W. Hand Company of Hamilton.

As they pass through the towns the children watching out the car window see Union Jacks flying everywhere and verandas lined with Chinese lanterns bobbing brightly in the chilly breeze. The trip seems endless and when they finally reach the cottage it is all boarded up, and with one shutter flapping loosely in the wind, it looks forlorn, so forlorn that one of the children is convinced it's haunted and won't leave the car.

The cottage smells airless and musty, but before long the wooden shutters are taken down, the creaky windows propped open, the mattresses hauled onto the front rock to air, the blankets hung out on the line and the drawers, full of chewed up acorns and mouse dirt, emptied and scoured with disinfectant. The children, each clutching a list of chores, work steadily, knowing that later, if they're good, they'll be rewarded. They'll stay up long after dark for skyrockets and pinwheels, burning schoolhouses and Roman candles, sparklers and serpents. The explosive sounds will echo across the lake and sprays of silver and gold and blue and red will soar up taller than the tallest pine trees. The air will smell of dynamite as they sit wrapped in plaid motor rugs, lighting sparklers and sipping hot chocolate with coloured marshmallows floating on top.

When one of them asks why we have firecrackers to celebrate Queen Victoria's birthday the adults seem unable to answer. But everyone agrees it's a grand excuse for a long weekend at the cottage and a fine beginning to another summer in Muskoka.

Lily pad, Lake Joseph

Country store at Utterson

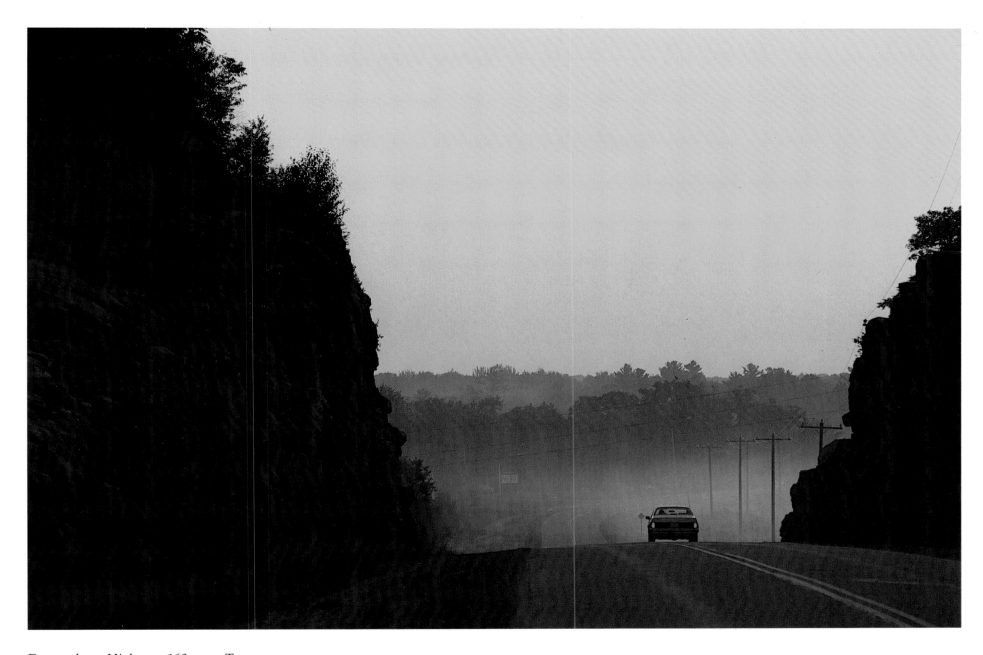

Dawn along Highway 169 near Torrance

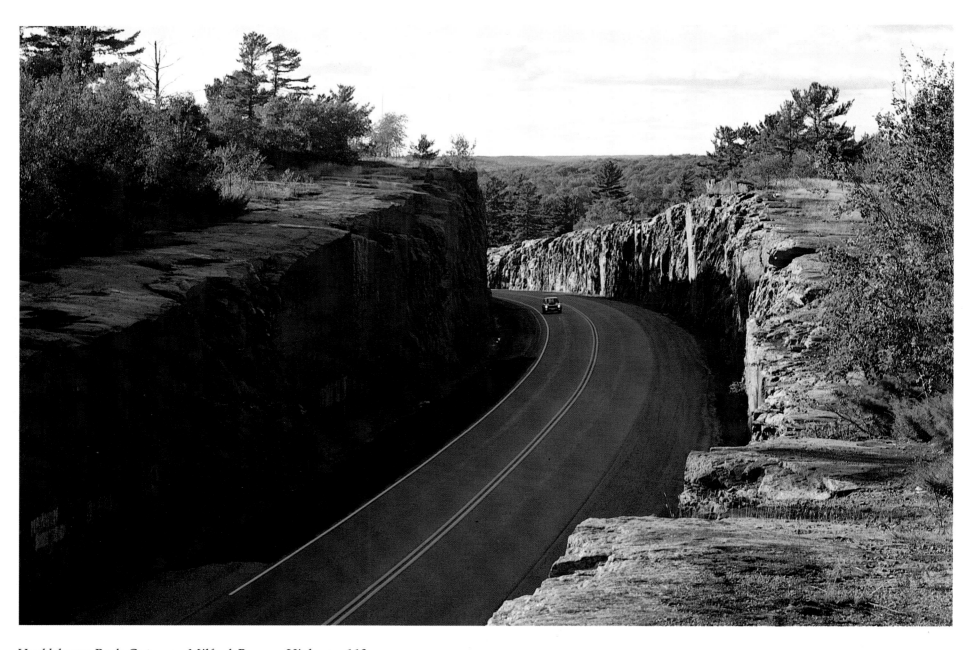

Huckleberry Rock Cut near Milford Bay on Highway 118

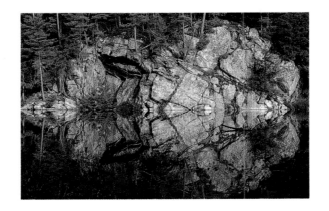

A ROCKY PLACE

Friday afternoon, anytime in the summer. Certain predictable stages define the drive to Muskoka: getting out of the city, pointing the car north on the 400, watching the city grime and smog leave the air, seeing the view change to patchwork fields and the rich black soil of Holland Marsh, passing strips of roadside stores and gas stations, sighting water for the first time in a distant glimpse of Lake Couchiching, stopping at Weber's for a burger (along with 7,000 others on a peak summer day), watching the landscape become more rugged, and then, just north of the Severn River, seeing the first outcropping of pink Muskoka rock and finally feeling at home.

This rock, the oldest on earth according to geologists, who identify it as preceding the Cambrian period of 590 million years ago, forms the character of Muskoka. When the last glacier swept across this land like a massive flood of ice, gouging out rivers and lakes, it left behind this incredibly beautiful landscape. As Henry David Thoreau once wrote, "The finest workers in stone are not copper or steel tools, but the gentle touches of air and water working at their leisure with a liberal allowance of time." In Muskoka, water and air have been working their magic on the rocks for a very long time.

Across the rock surface veins of lichen cast a grey-green haze and in some crevices there's just enough earth to hold clumps of velvety moss or a gnarled pine tree. Sometimes the rock rises straight out of the water in a perpendicular cliff, and other times it spreads out flat as a paved terrace,

warm and smooth underfoot and perfect for summer picnics. Then there are tiny uninhabited islands. Rocky and almost treeless, they rise from the lake like humpback whales, their barren shores a haven for nesting seagulls. The attachment to these chunks of pink granite is something maybe only a true Muskokan understands. Something happens when you've been bathed as an infant in a rock-formed bathtub, scraped your toddler toes on lichen and learned to run across a sloping rock face without falling. If you've spent childhood summers navigating a punt through shoal-infested bays, hopping across boulders like a bullfrog, and amassing rock collections, it's likely you've already formed a permanent attachment to Muskoka.

Still, without benefit of all this early rock lore imprinting, there's one display of Muskoka granite that impresses almost everybody. It's the rock cut about ten miles from Bracebridge on Highway 118. Almost half a mile long, with sheer sides of dazzling pink that soar up 40 feet, it was blasted out by roadbuilders in 1962. Known as the Huckleberry Cut, in some places the rock is so smooth it appears to have been sliced with a sharp knife. It's so impressive that Muskoka folk sometimes get positively zealous at the mere sight of it. When Dorothy Duke, of the boatbuilding Port Carling family, first drove through Huckleberry Cut, she claims she "wanted to stop the car, jump up on the hood and sing 'O Canada' at the top of my voice."

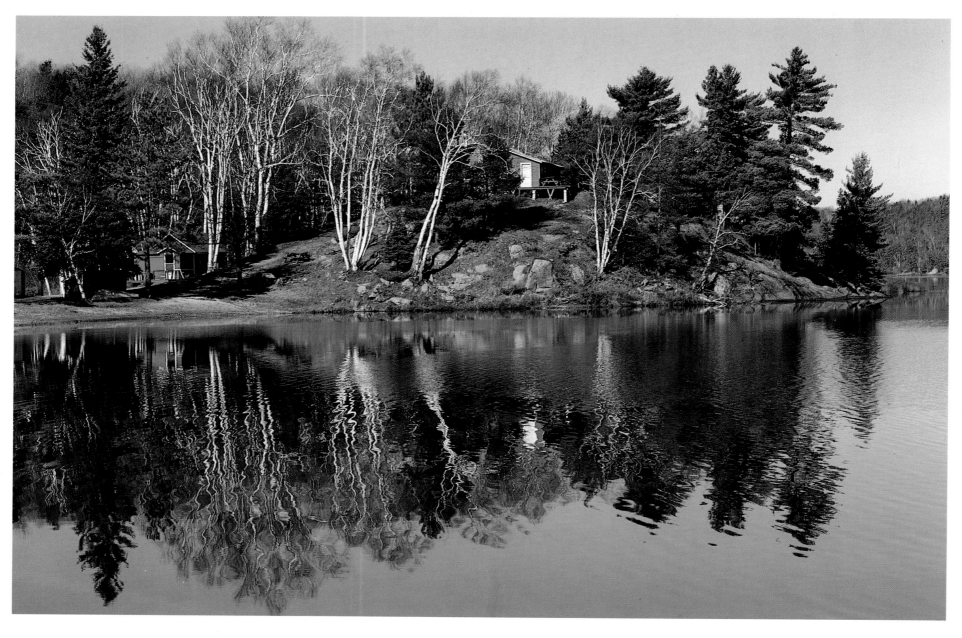

Northwest of Ravenscliff

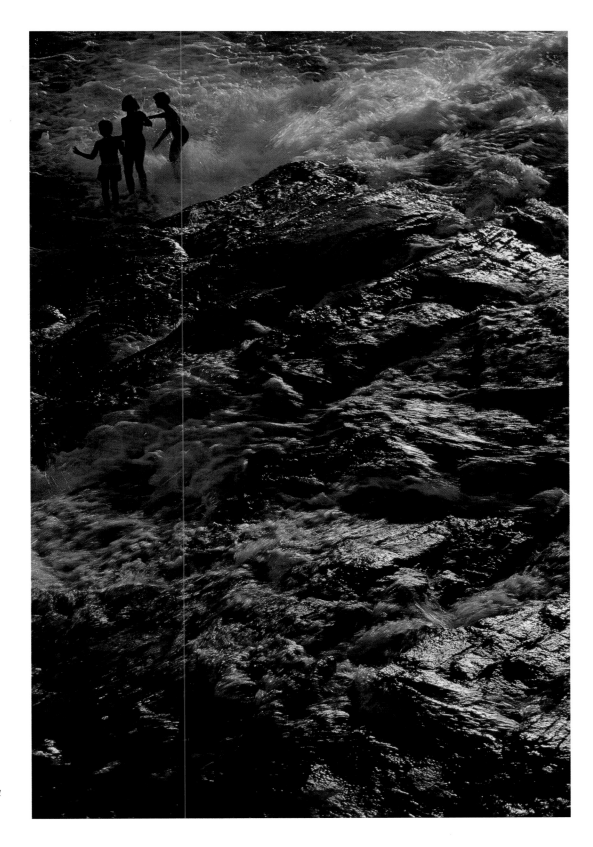

Moon River Falls, Bala

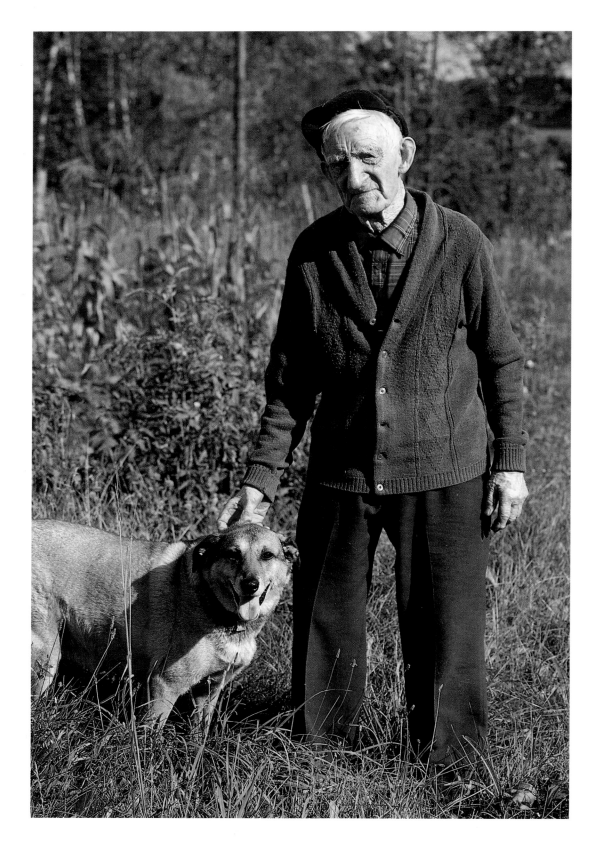

Fred Foreman and Rowdy

TO BE A FARMER

November 27, 1986. He's 90 years old and he's been farming this land for 60 years, bringing in the hay, growing vegetables, raising pigs and chickens at one time or another, and always feeding his cattle. Ever since he came here to this 750 acres he's had cattle, sometimes as many as 40 head. Now there are only eight, and today there's a truck coming to take them away. His sons have decided that he can't manage anymore. He doesn't look 90 and he can still swing an axe with the ease of a teenager, but even he admits that he "put in a tough winter." It was a long one with record snowfalls. He was constantly shovelling the path from the barn to the lake, and then chopping a hole in the ice for the cows to get water. It was tough, back-breaking work, and he got tired, tired enough that now the four cows and four calves have been sold and the truck is rolling down the dirt road to take them away.

"I wasn't gonna watch them, I wasn't gonna come out of the house." He still gets teary when he talks about it. "But they wouldn't go. They didn't want to leave. I had to put feed on the chute to get them to go. Those cows, I tell you, they're damn near human!"

Fred Foreman's story is not unlike many whose ancestors came to Muskoka to homestead during the days when free land grants were handed out by the government to entice settlers to the area. Between the years 1865 and 1875 thousands of hopeful farmers received 200 free acres with an extra 100 acres for each child over 18. For this, they agreed to clear two acres of land a year, construct a house,

keep up the roads and live in the house six months of every year. It seemed like a good deal.

But this is rock country. The vast Precambrian Shield, formed two billion years before, became covered with sheets of ice during the last glacial period, leaving clear deep lakes and stunningly beautiful shorelines. Some pockets of good clay and loam soils were deposited by the glacial lakes, but over the years these filled with debris, sphagnum moss, willow and ultimately big trees. Clearing this land was back-and heart-breaking work. Many gave up and headed to less rocky pastures further west. Of those that remained, most turned to lumbering, roadbuilding and the tourist industry to make their living.

Like his father, Walter Foreman, who owned Havington Inn on the Indian River and rowed to Lake Rosseau every summer day to deliver eggs, milk, butter and vegetables to the cottagers, Fred combined farming and running a tourist guest house. He and his wife had 12 bedrooms available, grew all the vegetables, did all the cooking, ran the post office, sold milk, butter and eggs to the cottagers, operated the farm, and then, when he had extra time, he built roads with his team of horses.

"Most of us farmed in a kind of a way," Fred recalls, "but they were all small farms here and we had to do many other things to make ends meet."

Before buying his farm Fred and his team of horses cleared the land for the Muskoka Lakes Golf and Country Club. "I put in three years building that golf course. It was

Near Aston Villa, Lake Muskoka

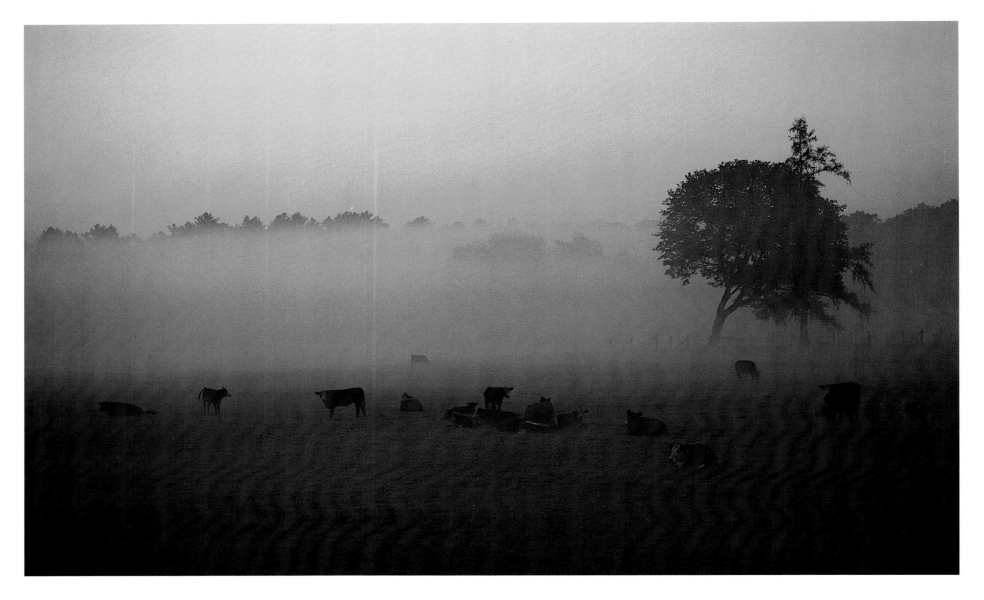

Dawn near Glen Echo, Lake Muskoka

a huge farm that had been let go and grew up in willow bushes. It was tough work. We worked ten-hour days using a team of horses. We got paid $4.50 a day for a man and team, but seeing as I was boss I made $5.50 a day. That's how I got the money to buy my farm in 1926. I paid $6,000 for 750 acres — that was all the money I could scare up!"

Farming was at its zenith in Muskoka in the twenties, with about 2,000 in full operation, many of them busy supplying the burgeoning tourist industry and lavish hotels.

Today there are only 225 small farms, including Fred Foreman's. But now, for the first time since the Foreman land was cleared, no cattle graze here. In the field the gates are left open, the hay has grown higher than the fence posts, and the barn looks abandoned. His cows live now on a farm just a mile or so down the road, but Fred still misses them. When he passes by them in a car, he turns his head in the other direction.

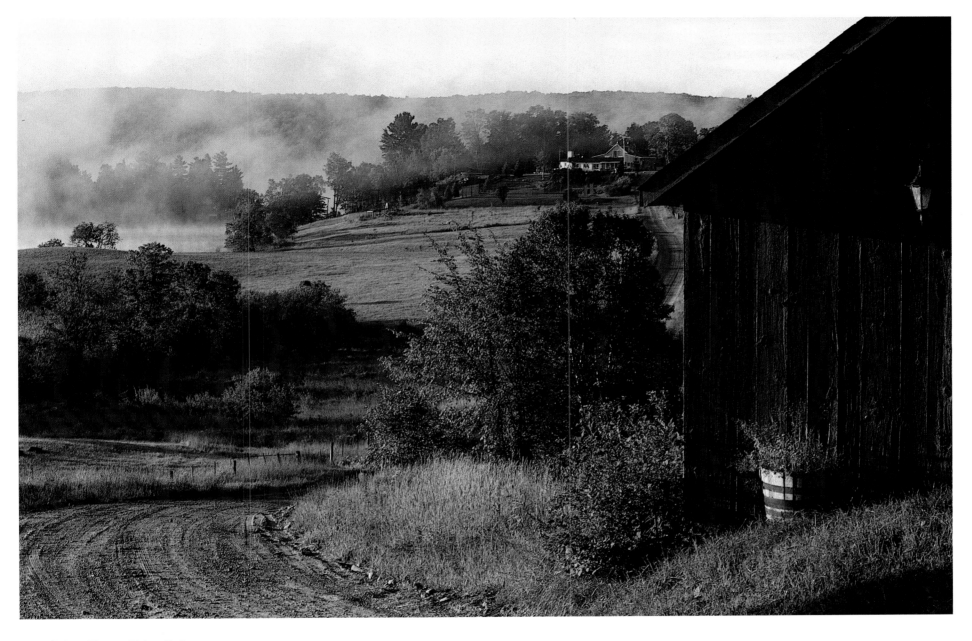

Grandview Farm, Fairy Lake

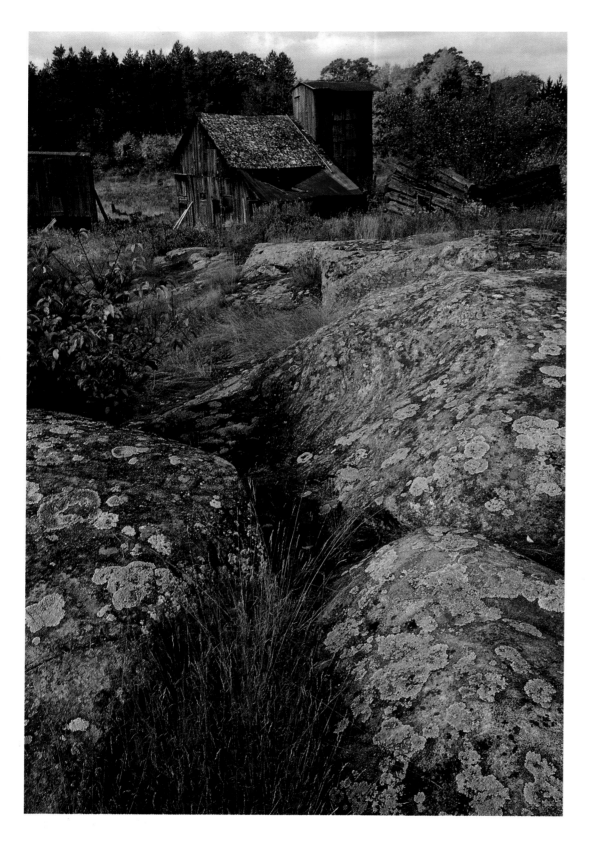

River Road near Bracebridge

Partridges' Garden outside Bracebridge

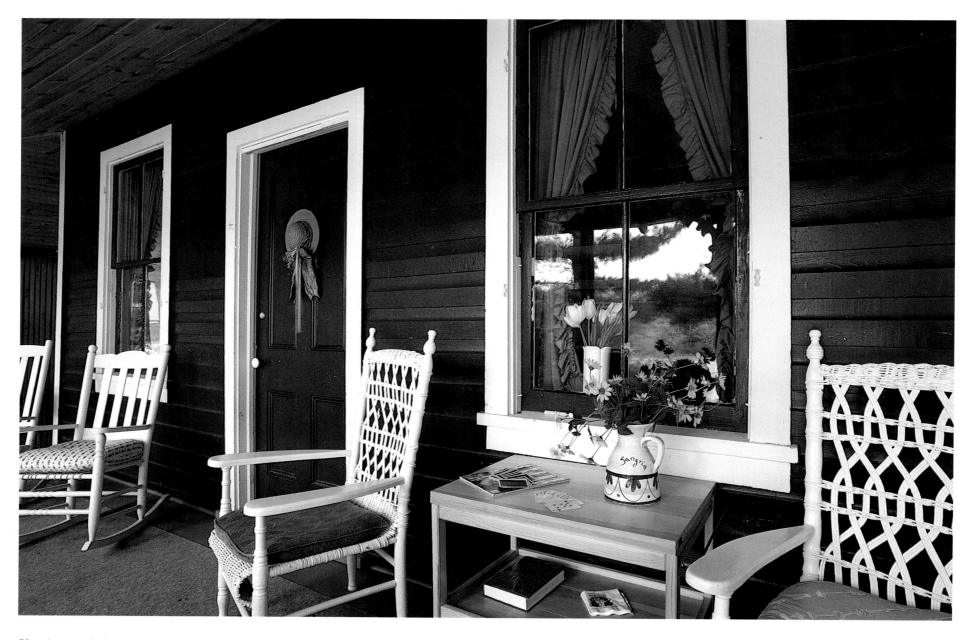

Classic Muskoka, Milford Bay

EARLY COTTAGES

"...without much hazard of prophetic failure, the day may be predicted, and not far distant either, when the wealthy in our large cities will erect villas for the summer residence of their families on the healthful and enchanting shores of Lake Muskoka." (Northern Advocate 1870)

They did come, the wealthy and the adventuresome, to buy land and to build their summer homes. The first known group of cottagers bought islands on Lake Joseph, and soon after a group of Americans settled around the Beaumaris area of Lake Muskoka. Often families spent their first few summers camping or in tourist lodges while the cottage was being built.

For some the cottage was a mansion with vast wings to house the servants, an imposing boathouse for the steam launches and runabouts, and an icehouse and storage cellar out back. The kitchen, manned by servants, was small, but the living room was expansive, large enough for a Muskoka rock fireplace, plenty of wicker chairs and sofas, and an upright piano, the focus of evening entertainment. (So essential was the piano that advertising for a local piano firm proclaimed: "The summer outing is robbed of half its charm if music is made impossible by want of a piano.")

Rimming the outside of the wooden cottage was a covered veranda where the ladies of the house languished in rocking chairs, needlework on their laps, fans at their side, and skirts down to their ankles. The men rarely sat here during the day, busy instead with fishing and canoeing expeditions.

Inside the cottage was dark. Small windows and wood panelling kept the rooms dark and cool even on the brightest summer day. The walls were lined with basswood and most of the furniture was made of local wood. All this building created such a demand for cedar, pine and basswood that the 17 sawmills along Gravenhurst Bay operated night and day. Local carpenters, busy non-stop all summer, spent the winter months building twig furniture, those unique chairs and tables that can still be found on vintage Muskoka verandas.

Upstairs, some of the sparsely furnished bedrooms had adjoining screened porches where family members slept on extremely hot nights. A washstand with freshly pressed linen handtowels occupied one corner. Down the narrow hall there was a morning room, a hearth-filled sitting area where the servants set out tea and scones for the early risers.

Many of these classic Muskoka cottages can still be found along the shores, well hidden in the tall pines and set back from the water. Often five or six generations of the same family have summered in them, tending their heritage so carefully that little has changed over the decades, even the furniture remains the same. As one long-time cottager explained, "It's important to have something in your life that doesn't change. For our family, it's the cottage."

Island cottage, Lake Muskoka

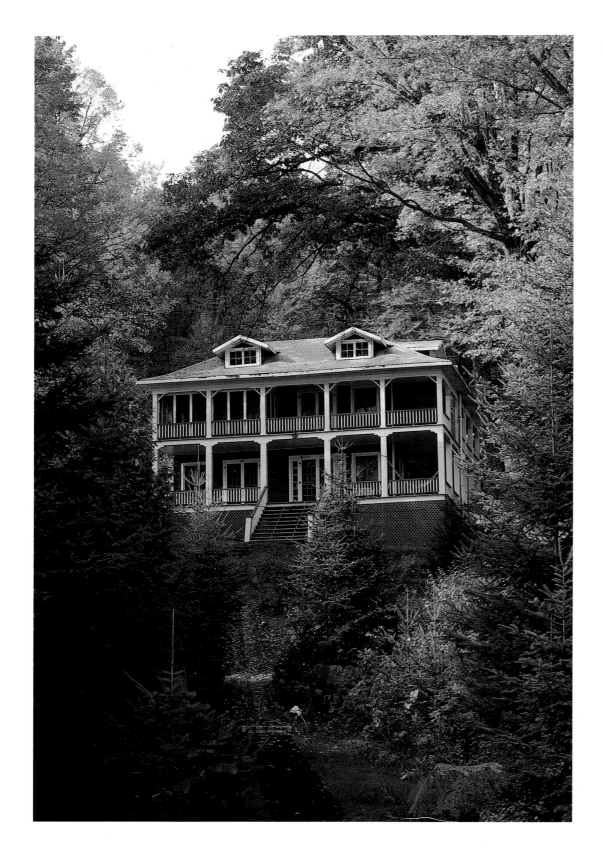

Norway Point, Lake of Bays

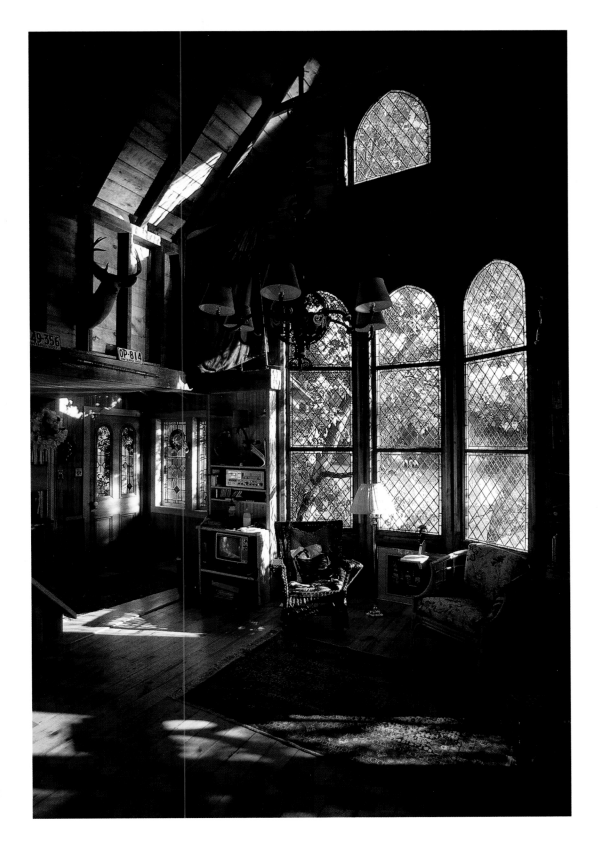

Mortimer's Point, Lake Muskoka

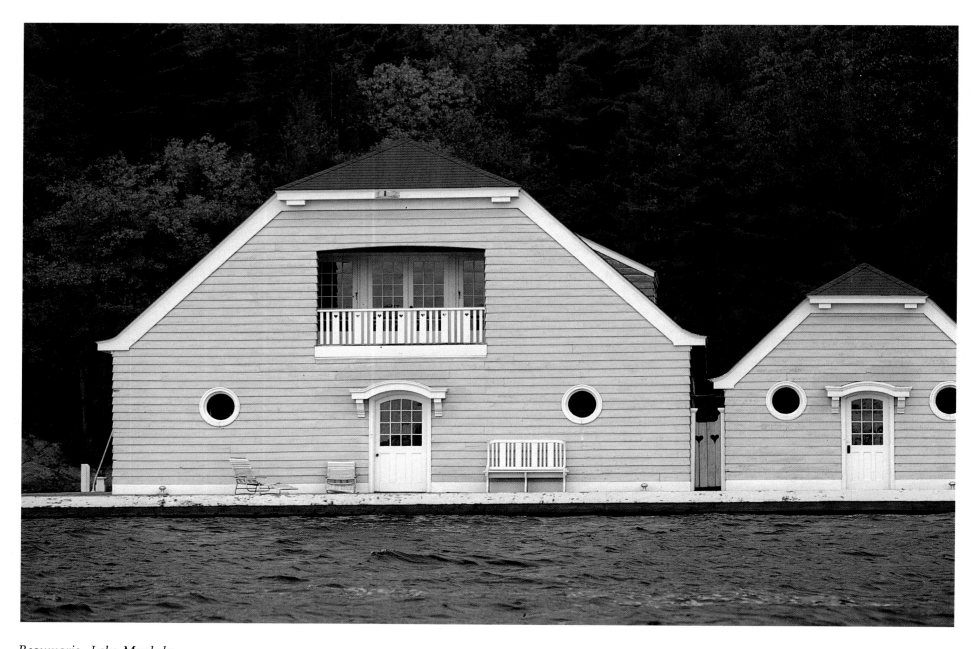

Beaumaris, Lake Muskoka

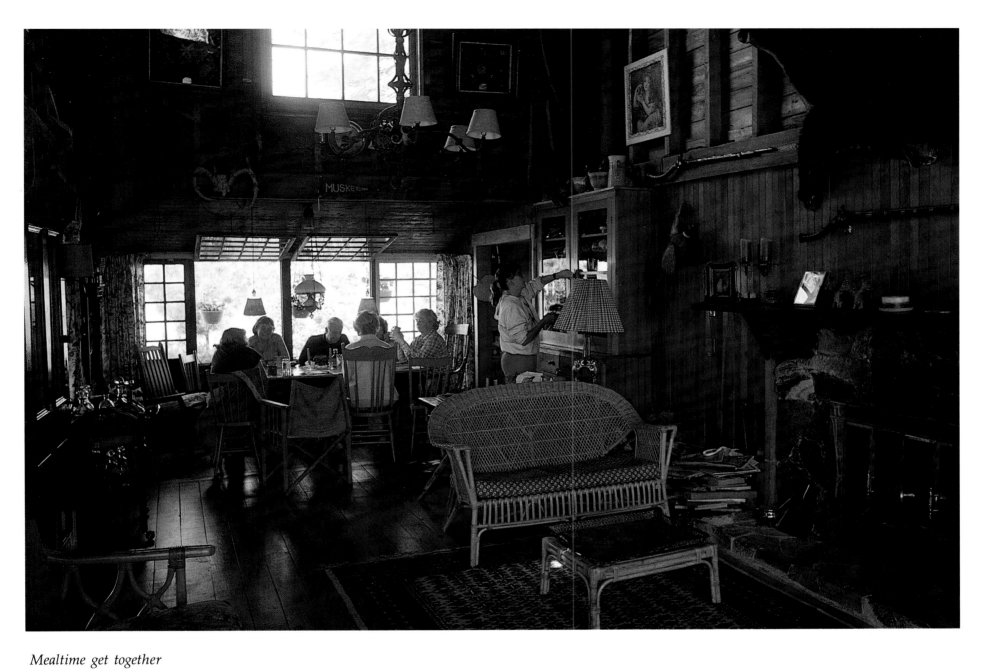

Mealtime get together

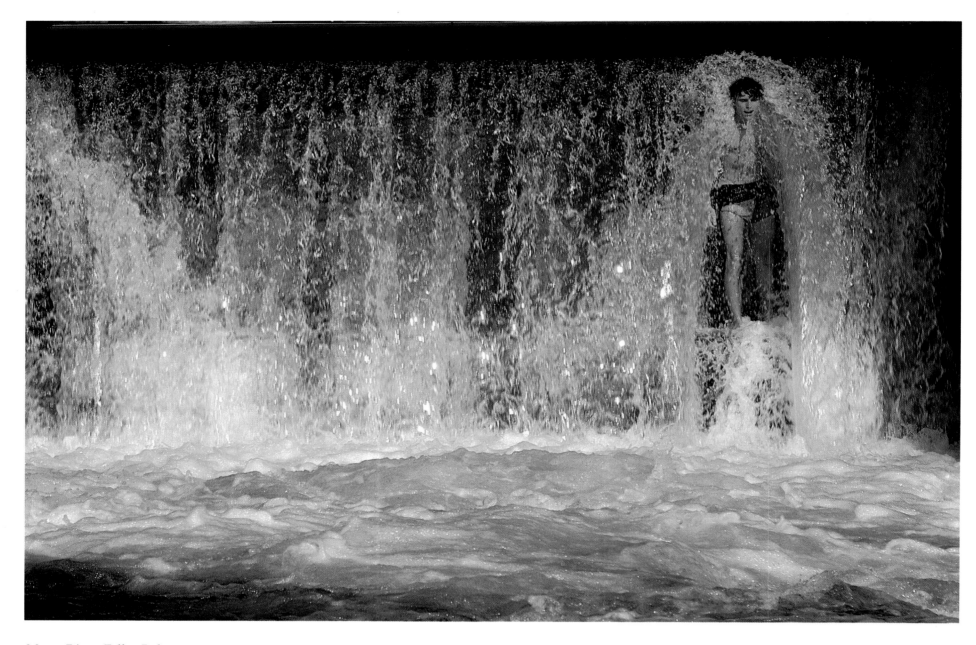

Moon River Falls, Bala

MIDSUMMER'S DREAM

July 29. It's a dream of a midsummer morning. The lake, still quiet before the noisy boat kids get out of bed, shimmers like a Monet painting in brilliant blue. Only the slightest zephyr of a breeze whispers through the pines. Nothing moves, except a jet stream slowly etching across the sky, a distant plane heading who knows where.

At skinny dip rock, where naked bodies have been plunging into the velvety coolness of the lake for as long as anyone can remember, the surroundings have hardly changed. The trees have grown a little taller on a neighbouring island and the old dead pine that towered above them all as a landmark for boat travellers finally toppled over last winter. Another neighbour built a new cottage, but it's a mirror image of his boathouse and set back in the woods so it barely changes the view. For decades Muskoka has thrived on barely changing.

"Going to the cottage" has meant the same thing to generations and evoked the same memories of long childhood summers: damp wooden cottages that groan in the wind and rattle in the rain, creaky screen doors slamming shut on spring latches, the smoky scent of burning marshmallows and charred weiners that have fallen into the fire, apple juice cans full of wild blueberries picked with the promise of a home-baked pie, flannelette sheets on slightly damp mattresses, sunny days spent mastering a swan dive from the top of the boathouse, rainy days spent fighting over Monopoly, raspberry Freshie spilled on kitchen linoleum,

bookshelves jammed with musty paperbacks, *National Geographic* magazines and a yellowed guest book filled with scribbles of long-forgotten summers.

But change is coming. On the far north shore, just within view, is a newly built cottage. It's a grand place, hardly a cottage at all, a permanent home with marble bathrooms, whirlpool tubs, expensive windows, landscaped gardens, cantilevered decks and every conceivable appliance in the ceramic-tiled kitchen. One of the old-time builders in the area remembers the day, not so long ago, when "you got hired to put up a cottage, plain and simple. Two bedrooms here, probably a fireplace of Muskoka rock, lay some linoleum on the floor and that was about it. But now, with some of these places we're building, why we're dealing with architects, engineers, landscapers — even interior decorators are getting into the act!"

Not that Muskoka doesn't have a precedent for this sort of building. Back at the turn of the century wealthy cottagers (many of them American) built lavish summer homes, particularly in the Beaumaris area of Lake Muskoka. The current building boom seems almost a renaissance of that time and no doubt a century from now these glittering cottages will be regarded with the same reverence as those along Millionaires' Row at Beaumaris.

Perhaps, even in Muskoka, the more things change the more they stay the same.

Island deck

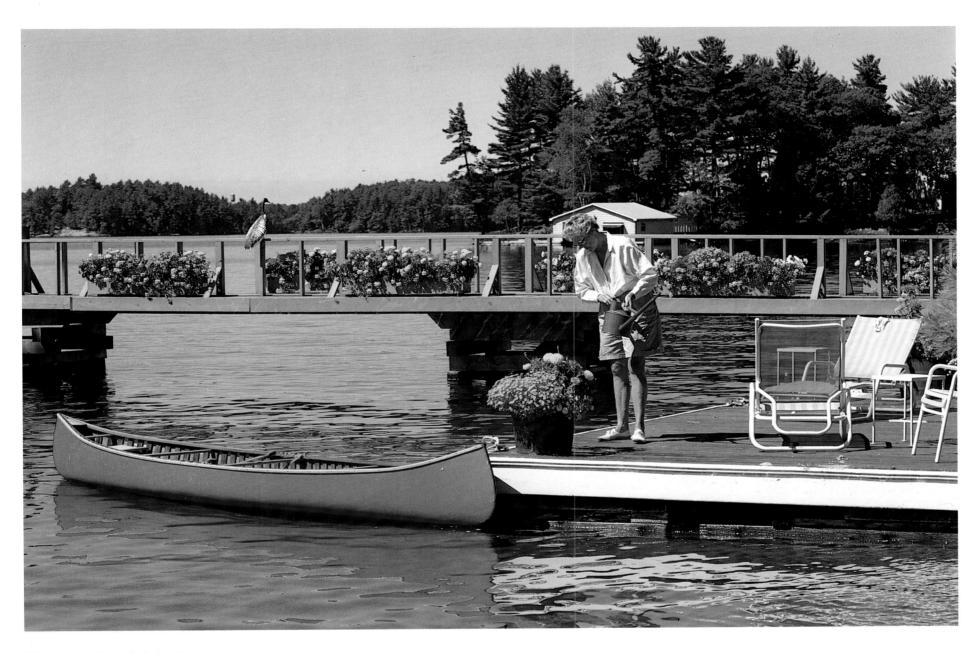

Hide Away Island, Lake Rosseau

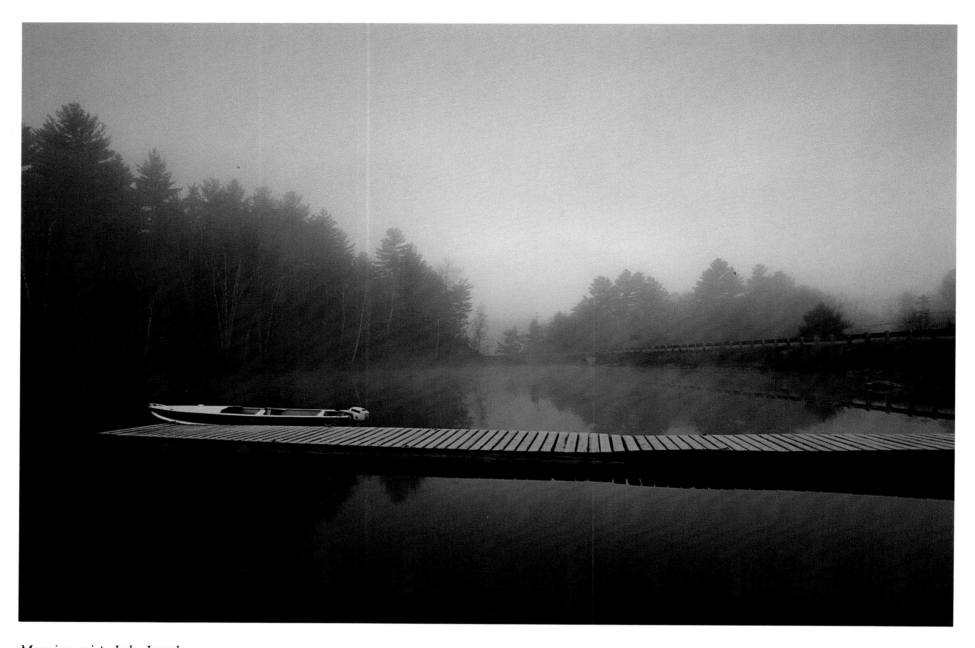

Morning mist, Lake Joseph

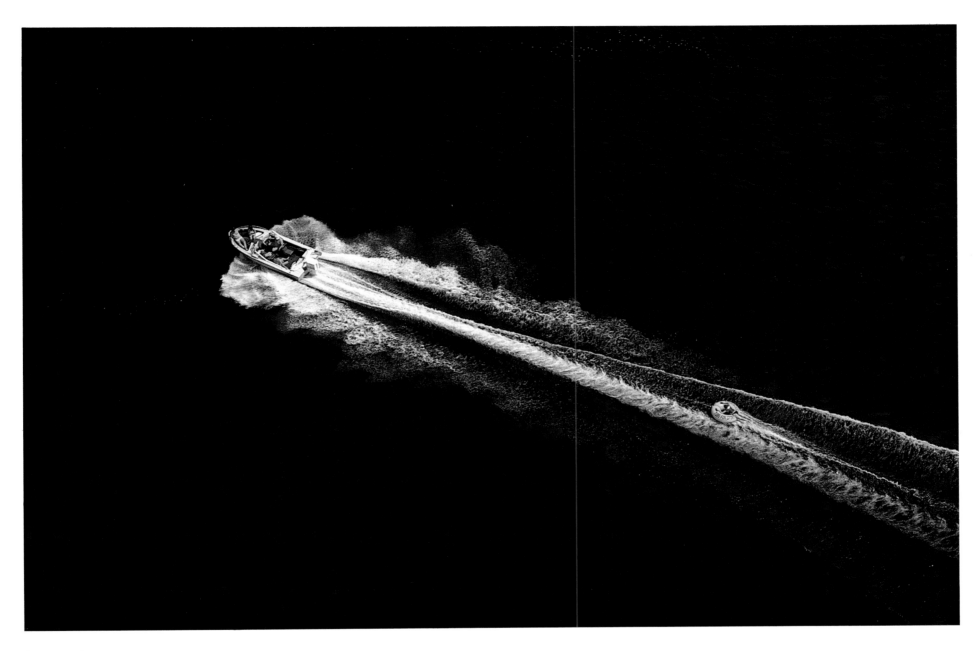

Summer fun

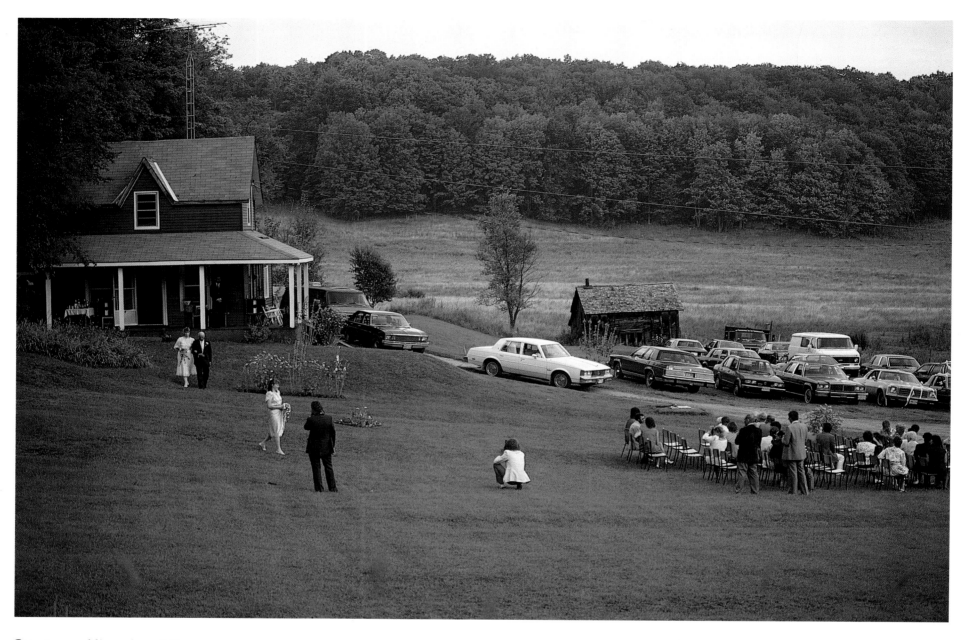

Country wedding along 141

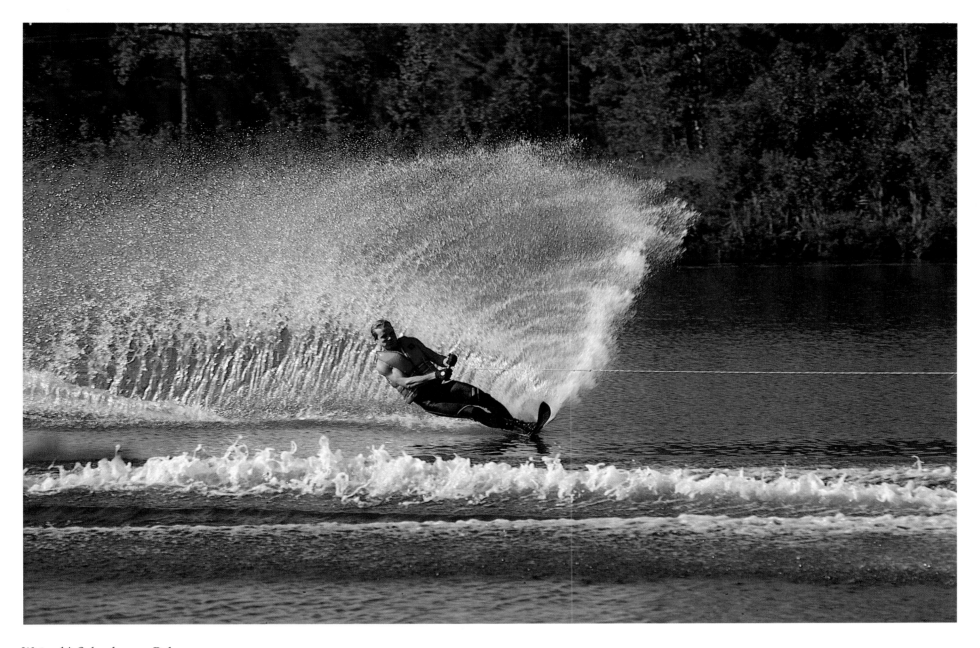

Waterski School near Bala

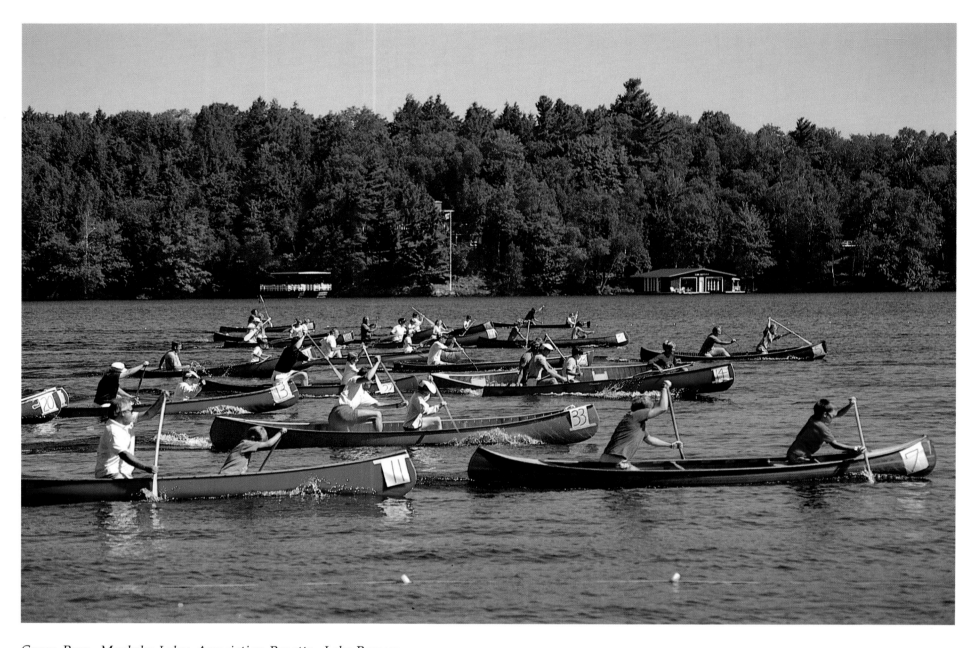

Canoe Race, Muskoka Lakes Association Regatta, Lake Rosseau

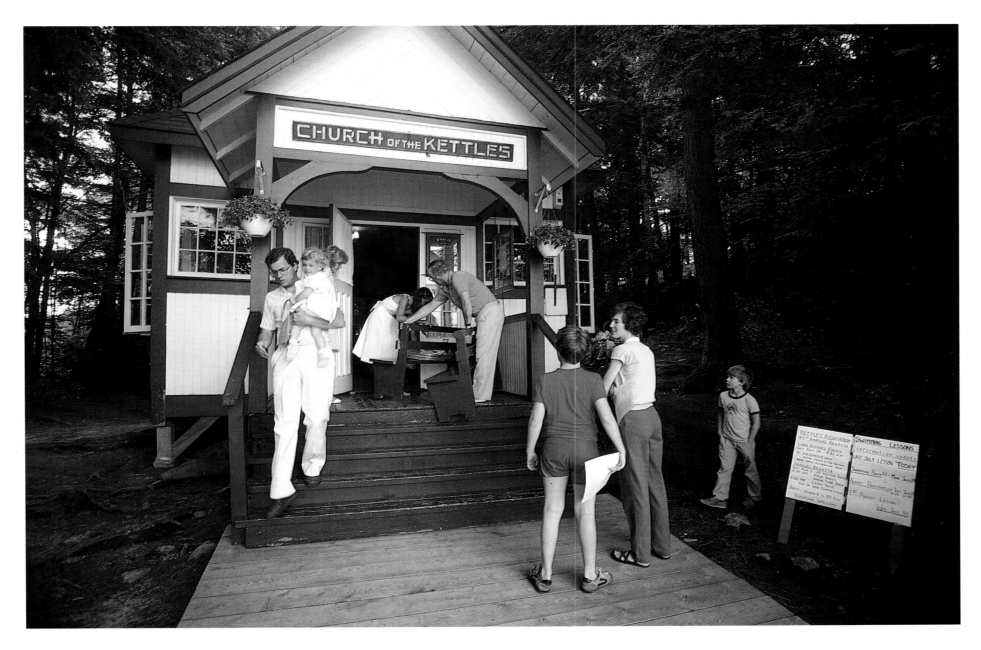

Church of the Kettles, Lake Muskoka

Strolling in Port Sandfield

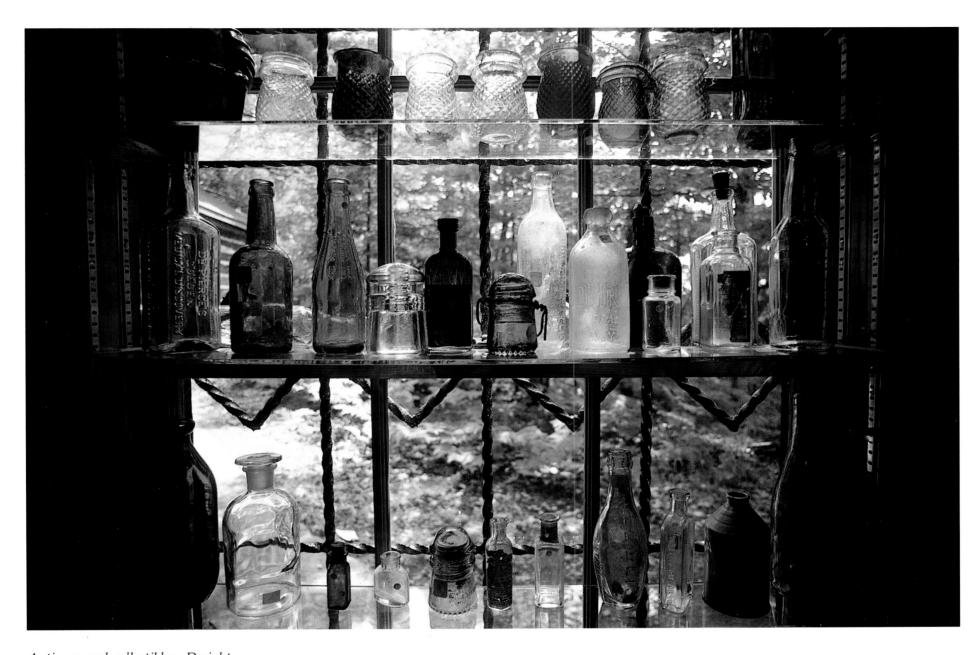

Antiques and collectibles, Dwight

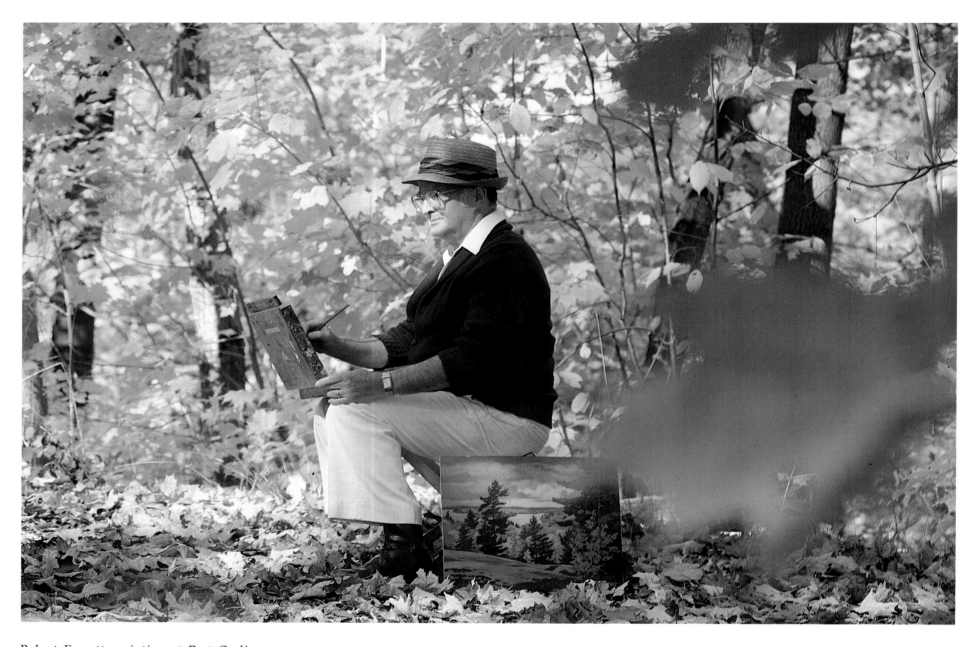

Robert Everett, painting at Port Carling

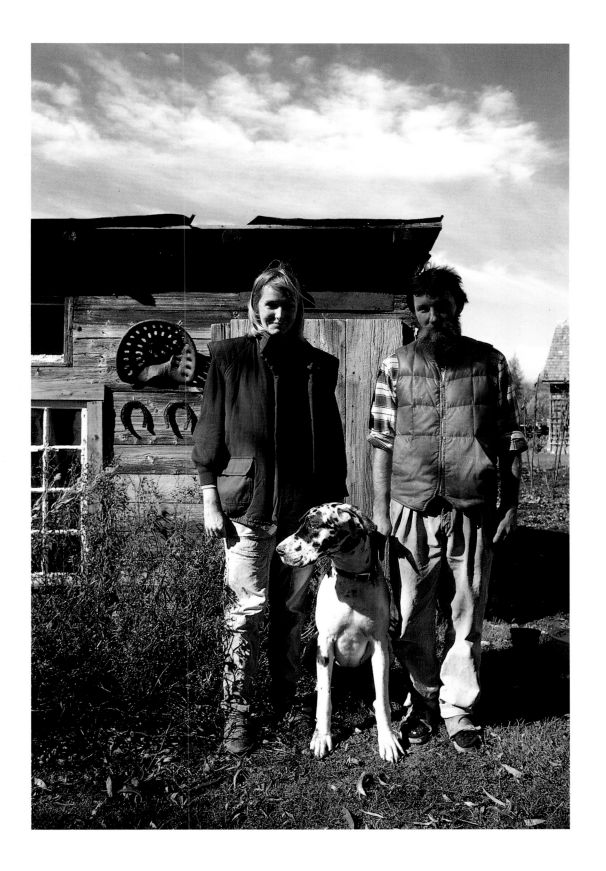

Suzann and Jon Partridge with Moose,
outside their pottery showroom

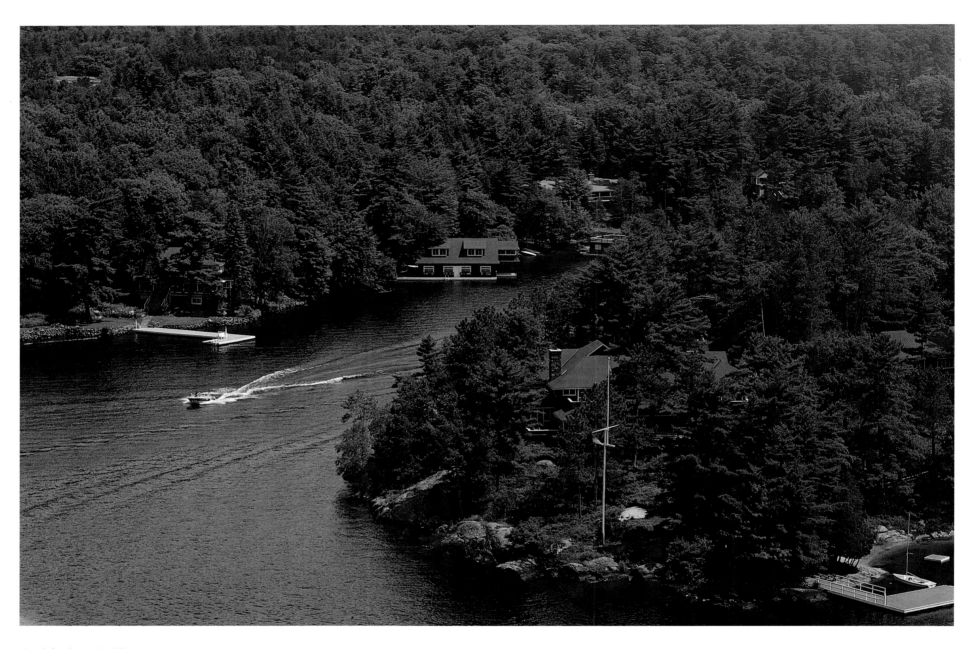

Aerial view, Millionaires Row

BEAUMARIS... Then and Now

October 16, 1873. The day is crisp and clear, and with little wind the lake ripples gently under sunny skies. The spectacular coloured trees along the shore are still at their peak as the steamer *Waubamik* wends its way from Gravenhurst across the cobalt-blue lake. On board are two families from England who have come to settle on Tondern Island in Lake Muskoka. They have left Toronto three days ago and have been travelling by train, stagecoach and steamer in a large family group, including a baby and a 66-year-old grandmother. With them are crates full of fine linen, china, clothing, suites of furniture, and other vestiges of their life in England, including an upright piano.

After landing on the rocky, pine-studded shore, they choose the name "Beaumaris Landing" because of fond memories of a seaside resort in Anglesea, Wales, where their families have spent enjoyable summer holidays.

Despite the obvious contrasts with their life across the ocean, and the hardships of settling in this new untamed land, these two families dug deep roots, and their names, Prowse and Willmott, would continue to be associated with Beaumaris more than a hundred years later.

Edward Prowse, the father of four children, fathered four more after his arrival in Canada, and his brother-in-law John Willmott became father to nine, so there were plenty of descendants to carry on both family names.

Willmott built a house (which still stands beside the grocery store) and for the first few years the men were busy clearing land and farming, until 1880, when Edward Prowse decided to build a hotel, a large and splendid hotel that would forever change the character of this tiny farming settlement. A brochure of the time described it this way: "Beaumaris is situated on Tondern Island, on a breezy eminence, commanding an extensive view of Lake Muskoka and distant islands. The hotel itself lies at the end of a deep bay, and, as viewed from the deck of the approaching steamboat, creates a most favourable impression by its imposing appearance. A closer acquaintance with Beaumaris and its genial proprietor, Mr. Edward Prowse, but serves to strengthen this impression."

The hotel could accommodate 200 guests with large, lofty rooms and a wide verandah "well adapted for promenading, and for shady afternoon siestas." There was also golf, lawn tennis, cricket, dancing, concerts, billiards, bowling, bicycling, fishing, and boating. And, boasted the brochure, "a good table is kept, fresh meats, vegetables, etc., being supplied from the adjacent farm." The daily rate ranged from $1.50 to $2 a day.

Even before the hotel was built the area had begun to attract a group of wealthy Americans, in particular those in the steel and oil business in Pennsylvania. In those days Muskoka was the easiest summer resort to reach from Pittsburgh because of direct train connections to Gravenhurst. Since Beaumaris was the first port of call for the steamboat, many simply disembarked, and stayed. Initially they came for different reasons. Some came to fish and camp, some to escape the sweltering city heat, some to alleviate their suffering from hay fever. But many became so enamoured with this Canadian wilderness that they bought property

Beaumaris cottage interior, Lake Muskoka

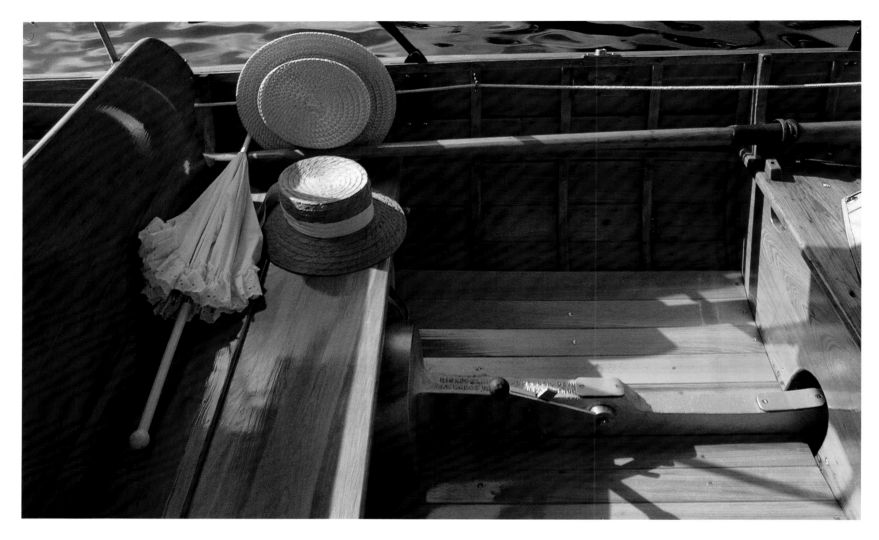

Classic 'Dippy', Beaumaris

and built grand summer homes for their families. Many of their descendants still summer here. They come to renew traditions and old friendships, to gather with family from all over the world, and to relive the memories of summers long ago. And they love it because it never seems to change.

Indeed it doesn't. Beaumaris today has fewer buildings than when the Prowse and Willmott families arrived in 1873, and even though its name connotes a certain panache, and the cottagers docking at Beaumaris wharf have the look of quiet old money, the place itself is very ordinary. There's a large government dock originally built for steamers, a marina, a post office, a grocery store, a short-order restaurant attached to the marina, an unpretentious

boutique and a Victorian clapboard church. The large Prowse hotel burned down in July 1945 and on its site is the rambling Beaumaris Yacht Club, which was originally a six-bedroom shingled cottage.

About the only exception to the ordinary look of Beaumaris is the lovely big white house beside the grocery store, the one built by John Willmott over a hundred years ago. Recently it's had a facelift to become the office of Johnston & Daniel, a leading real estate firm in the area. And the saleswoman for this real estate firm who's almost an institution in the area is Bernice Willmott, widow of Norman, youngest of John Willmott's nine children.

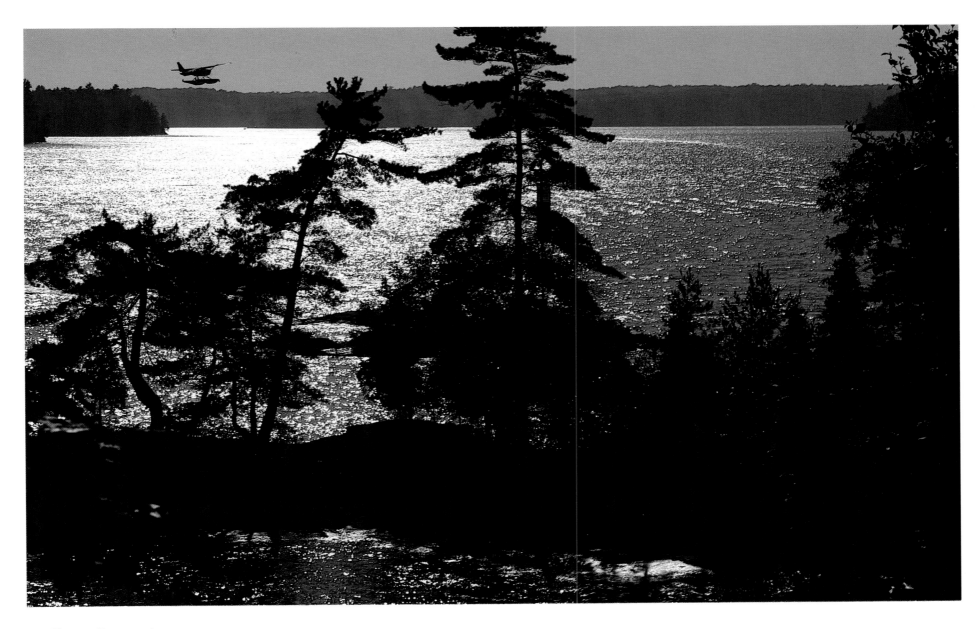

Landing at Beaumaris

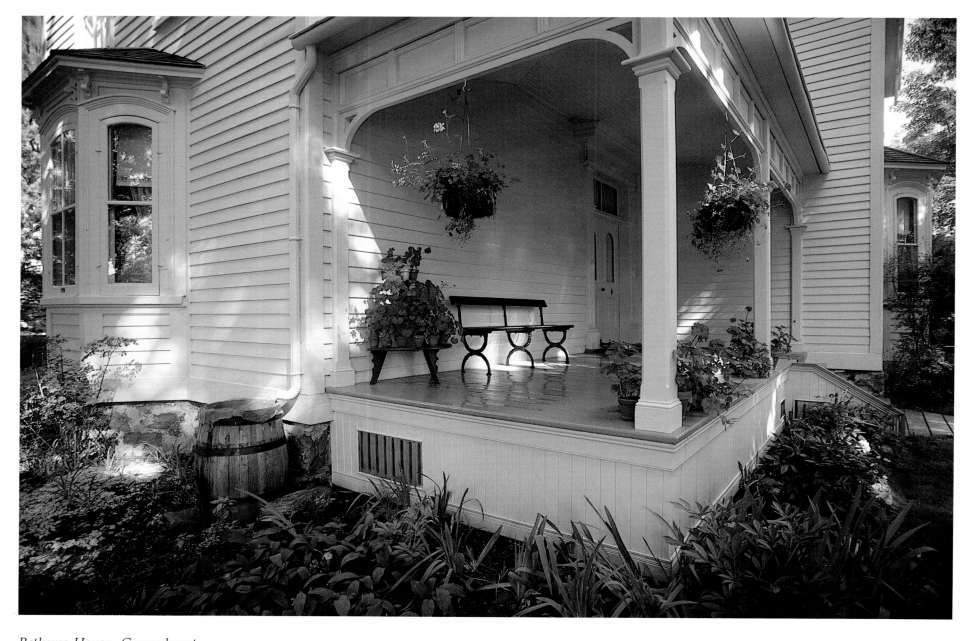

Bethune House, Gravenhurst

MUSKOKA'S FAMOUS SON

March 3, 1890. Gravenhurst, a lakeside town of 2,500 people at the south end of Lake Muskoka, is an active lumbering centre with 17 sawmills around its still frozen bay and dozens of lumber camps along the shore. It's also the terminus of the Grand Trunk Railway, where all summer long passengers from Toronto transfer to steamboats to continue their journey to cottages and hotels on the three main lakes. On winter days like this, it's much quieter.

The newly ordained minister at Knox Presbyterian Church is 33-year-old Malcolm Bethune. He lives in the manse at the corner of John and Hughson Streets with his wife, Elizabeth Ann, and two-year-old daughter, Janet. On this bleak March afternoon, in the heavily draped second-floor bedroom, Elizabeth Ann gives birth to a baby boy. They name him Henry Norman. The baby's paternal grandfather had been one of the founding doctors of the medical faculty of Trinity College in Toronto, and this child, growing up in his grandfather's footsteps, will become one of the most revered medical doctors of the twentieth century.

Norman Bethune became known as a skilful surgeon in Montreal, but it was in Spain and China that his brilliance and dedication attracted attention. He began a mobile blood bank which saved hundreds of lives during the Spanish Civil War. Then, in 1938, he went to China to work in the battlefields of the Second Sino-Japanese War. Here his devotion to teaching and treating the wounded earned him a revered status. When he died from blood poisoning in 1939, Mao Tse-tung wrote an essay, "In Memory of Norman Bethune," that is still required reading for school children in China.

The Presbyterian manse where Bethune was born still stands at the corner of John and Hughson streets. A comfortable clapboard house with a wide veranda and green expanse of lawn, it has been restored by Parks Canada as a memorial tribute and is open to the public. Eighteen thousand people came to see Bethune's birthplace last year, over 1,000 of them Chinese. They come in busloads — politicians, sports teams, businessmen. Almost every delegation that comes to Ontario finds its way to Gravenhurst, a town better known to the Chinese than Toronto or Ottawa. They come to touch the baby's cradle, to see the lawn where Bethune romped as a toddler, to read the Chinese inscriptions on the showcases, to see the mural that he painted while suffering from tuberculosis, to watch the video of his life story, to sign the guest book. And always, as is the Chinese custom, they leave behind mementos of their visit, small tokens of their continuing reverence.

Bethune House, Gravenhurst

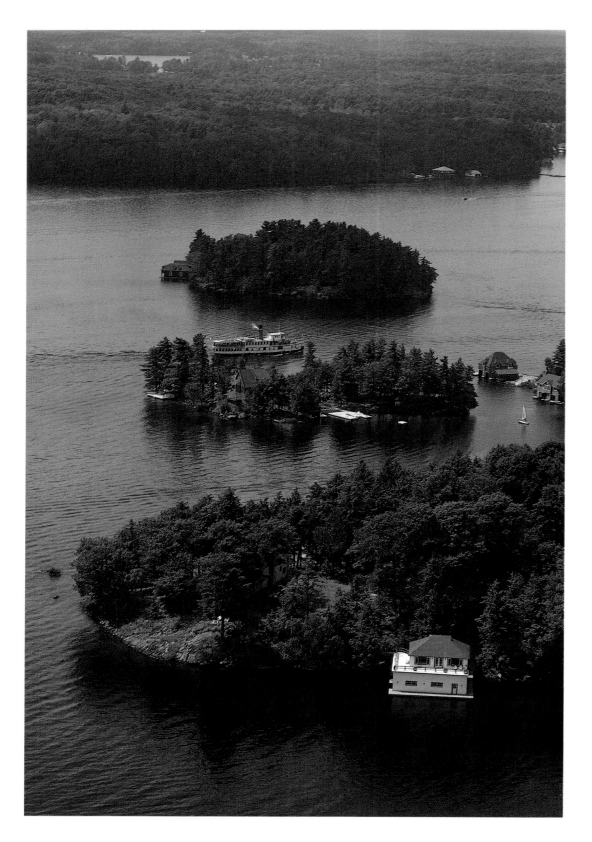

The Segwun en route

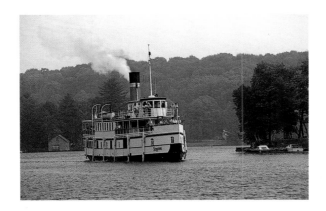

THE SAGA OF A STEAMBOAT

The *Segwun* began life in 1887 in Clydebank, Scotland, as a sidewheel steamer. Soon after, Mr. A. P. Cockburn of the Muskoka Navigation Company bought her to add to his growing fleet, one that would eventually number 140. Originally named the *Nipissing*, she delivered freight and mail to the settlers and transported tourists from the stagecoach landing at Gravenhurst to the lakeside hotels. When steamer travel was at its zenith, in 1925, the *Nipissing*, after suffering a fire and spending some time in dry dock, was rebuilt and renamed the *Segwun*, an Ojibway word meaning "springtime."

In those days Muskoka's reputation as a sparkling resort land was luring tourists from all over Canada and the United States. For most, the journey began in the high-ceilinged rotunda of Union Station in Toronto, where the *Muskoka Express* departed daily for Gravenhurst. Throngs of excited passengers gathered amid steamer trunks, wicker baskets, leather satchels, wooden cages containing family pets, bundles of bedding, lunch baskets, kegs of whisky, and tin pails full of fishing worms. All around them men in red caps raced to load everything on baggage carts for the waiting train. Three hours later (give or take several hours) the train shunted down a side line to the Gravenhurst wharf, where the steamboat lay waiting. Then the unloading and loading of baggage was repeated as passengers milled about, checking that all their goods and chattels were heading in the right direction. Once on board, they jostled to the front deck for the best view of the

magnificent Muskoka lakes, described in brochures as "the summerland of your dearest dreams." As clouds of black smoke belched from the smokestack, the steamer backed away from the wharf, turned slowly around and, with a blast of her whistle, sailed away from Muskoka Bay.

During the twenties the Muskoka Navigation Company, perhaps sensing the coming decline of steam-propelled lake travel, started the 100 Mile Cruise, which soon became a most popular tourist attraction and, ultimately, the company's salvation during World War II, when gas rationing and restricted European travel kept families close to home. Then, tourists rode the overnight train to Gravenhurst, boarding the steamboat in the morning for an all-day cruise up to the top of Lake Joseph and back.

After the war, increasing prosperity allowed people to buy cottages, and as more roads were hacked out of the woods, few cottagers required the services of a steamboat. By the 1950s the decline of the steamboat had been so rapid that only two remained of the fleet of 140 (not counting another 50 on the Huntsville lakes and the Lake of Bays), and on Labour Day 1958, these two, the *Sagamo* and the *Segwun*, were both retired.

June 1, 1974. Prime Minister Pierre Trudeau reached across a wooden platform, swung the rope with a deadly aim and cracked a bottle of champagne across the bow of the *Segwun*. Six thousand people, almost the entire town's population, crowded around the Gravenhurst dock on that gusty spring day, nudging and greeting each other in exuberant agreement

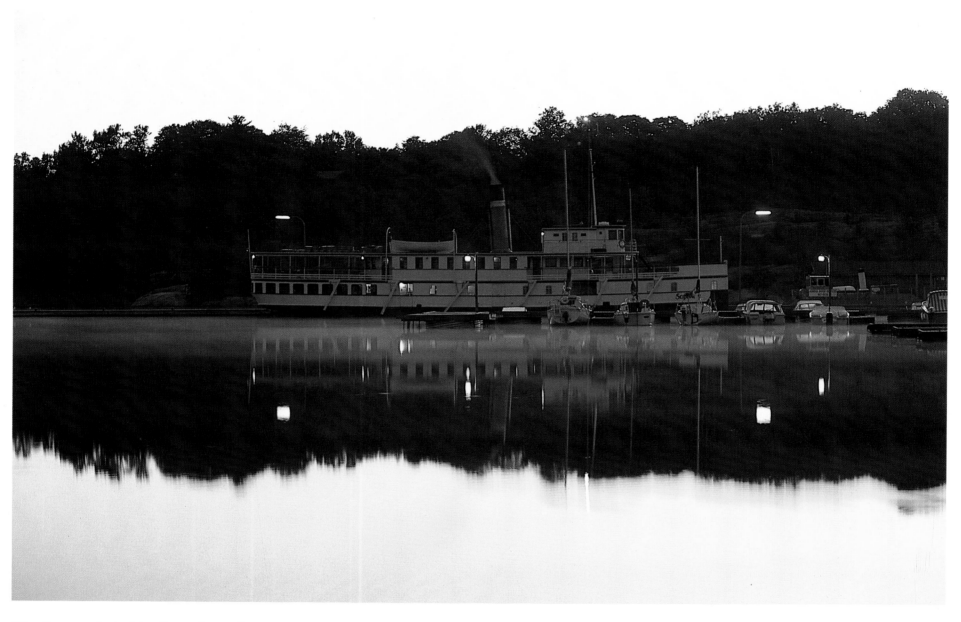

The Segwun docked in Gravenhurst Bay

that this was a great day for Muskoka. Whooping cheers rang in the air as the old steamboat groaned slightly and then slid into Muskoka Bay. The *Segwun* had been reborn — back where she belonged, in the deep blue waters of Lake Muskoka, and ready to sail again. Or so everyone thought. It would, in fact, be seven more years before she became fully operational, but, as the last remaining steamship of the Muskoka Navigation Company fleet, the *Segwun*'s

restoration had become symbolic, almost a mission, and a handful of heritage-minded steamboat buffs were determined to see her successfully afloat.

Today, like an old dowager who refuses to die, she glides proudly through the lakes all summer long, gleaming in brass and hand-rubbed wood, and blasting her whistle for all to hear.

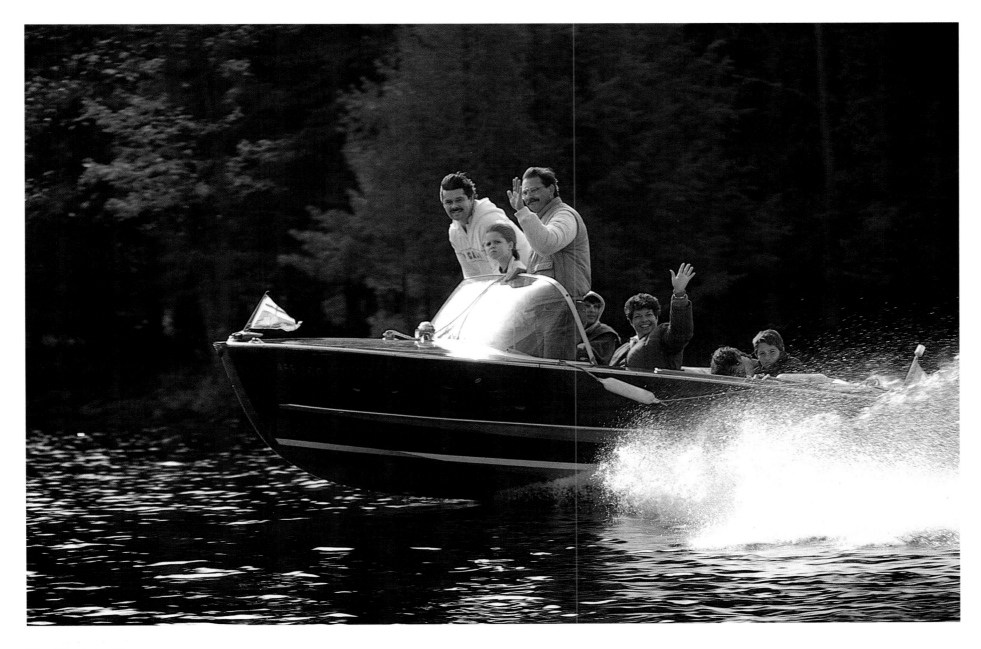

The Muskoka Wave

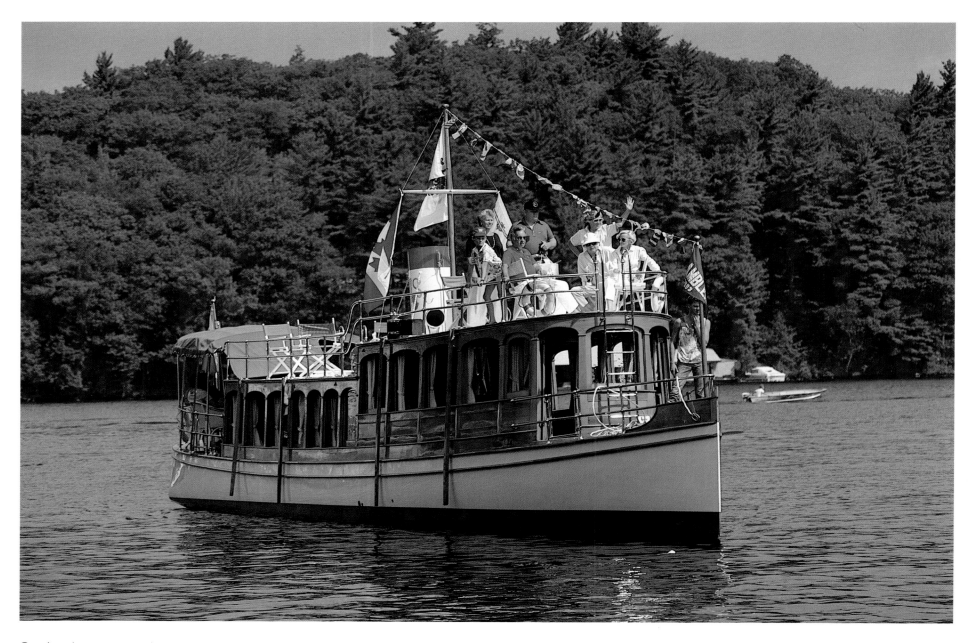

Coming in to port, Classic Boat Show, Port Carling

ANTIQUE BOAT SHOW

July 16, 1987. Occasionally a waft of west wind relieves the heat as thousands of people crowd into tiny Port Carling, the town known as the hub of the lakes. They're here for the seventh annual Antique and Classic Boat Show, the day when Muskoka's finest old boats get a chance to show off. Row upon row of these gleaming varnished vessels are tied with thick white ropes along the docks. People come from everywhere — bare-chested men with video cameras, babies in strollers, toddlers carrying balloons, children dripping ice cream cones, women wearing hats that could be pleated lamp shades, intense young men with binoculars, families seeking a shady spot to picnic on the island, and collectors quietly coveting the gems among the 150 antique boats on display. They meander up and down the narrow docks, clicking cameras, taking notes, and seeking out the owners to inquire about the history of these dazzling wooden craft.

At one time Muskoka was the custom-boat building capital of North America. By the 1890s local craftsmen, most of them trained as carpenters, were creating individual mahogany launches, steam yachts and sleek runabouts for the wealthy cottagers who used them to travel to their lakeside summer homes. Pioneers of the industry were William Johnston, Bert Minett and Henry Ditchburn. Then there was Audrey Duke, Thomas Greavette and others whose names are still lovingly attached to the boats they built. The heyday of boatbuilding continued into the thirties, with the builders outdoing each other in attention to detail.

Using only the finest imported mahogany, they finished these vessels with individually blended varnishes layered on coat after coat, with meticulous sanding in between. Gleaming brass and chrome fittings were attached and fine leather upholstery stitched to padded seats. But as the Depression dragged on, some companies went under, and ultimately, after World War II, the industry died altogether. Fibreglass was introduced to the boat world in the fifties, followed by aluminum and plastic, and soon these fine old boats were left to rot in boathouses. Like white elephants, there was a time when you couldn't give them away.

Then, in the sixties, there came a revival of interest in these floating antiques. Cottagers from old Muskoka families, some of them third and fourth generation, became curious about the fate of their ancestors' wooden boats and began rummaging in cobwebbed boathouse rafters and under old cottage verandahs. Their interest in these old vessels has created a thriving new industry of boat restoration, and more than a few enthusiasts are building bigger and bigger boathouses to dock their growing collections of antique boats. Still, it was only a small group who initially showed an interest. When the first Antique

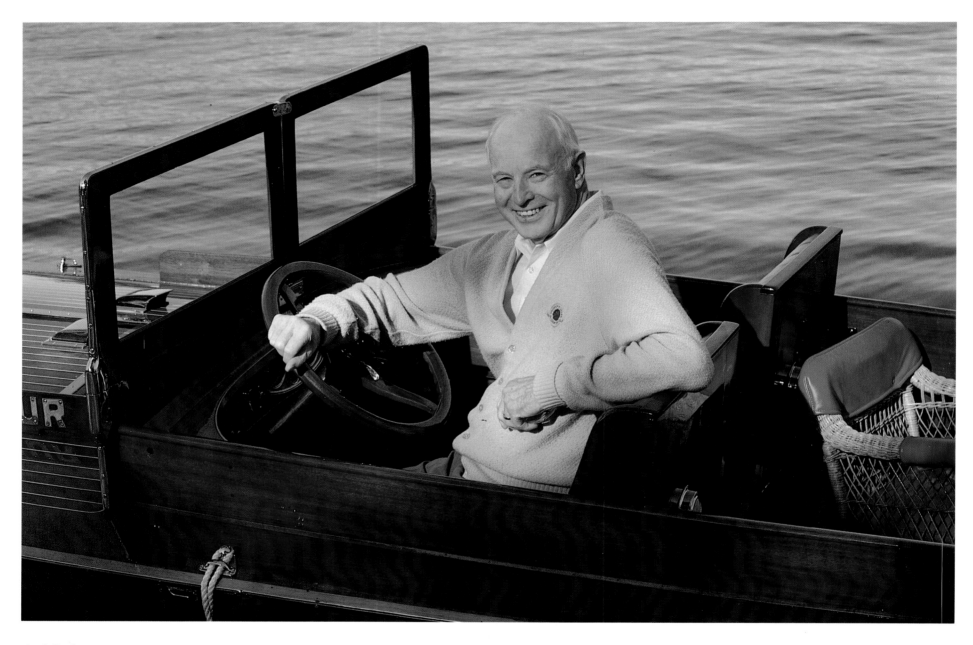

Aud Duke, Port Carling

Boat Show was held in Muskoka in 1971, only 500 people attended.

Today, on this sweltering Saturday, almost 20,000 people have left shady hammocks at their cottages or forsaken cooling swims to come to Port Carling, to sit in bumper to bumper traffic, to try to find a parking space, to jostle through the crowds in order to see these lovely mahogany ladies. Each one is decked out like a shiny new toy with her chrome gleaming, her flags flapping, her varnish glistening, her vital statistics neatly printed on a cardboard sign and, most likely, her proud owner standing not too far away.

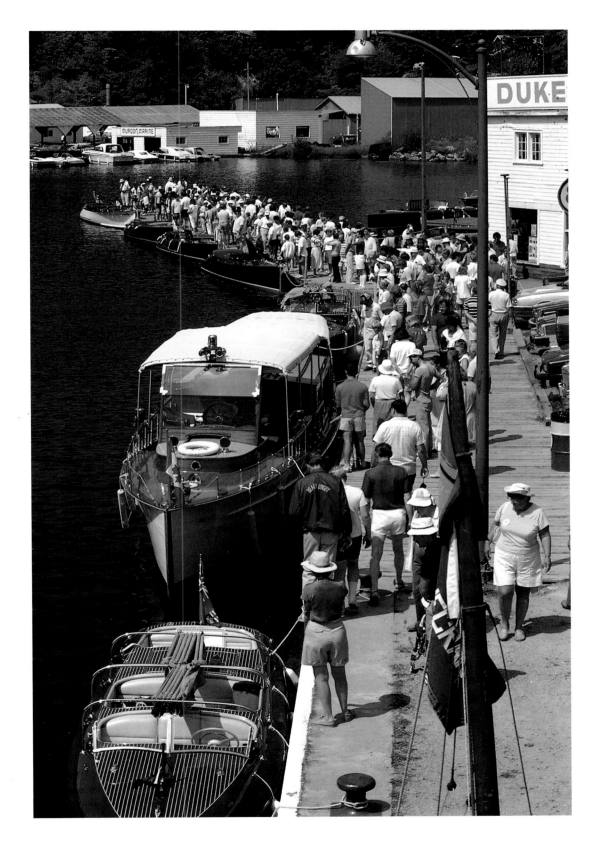

Crowd scene, Classic Boat Show, Port Carling

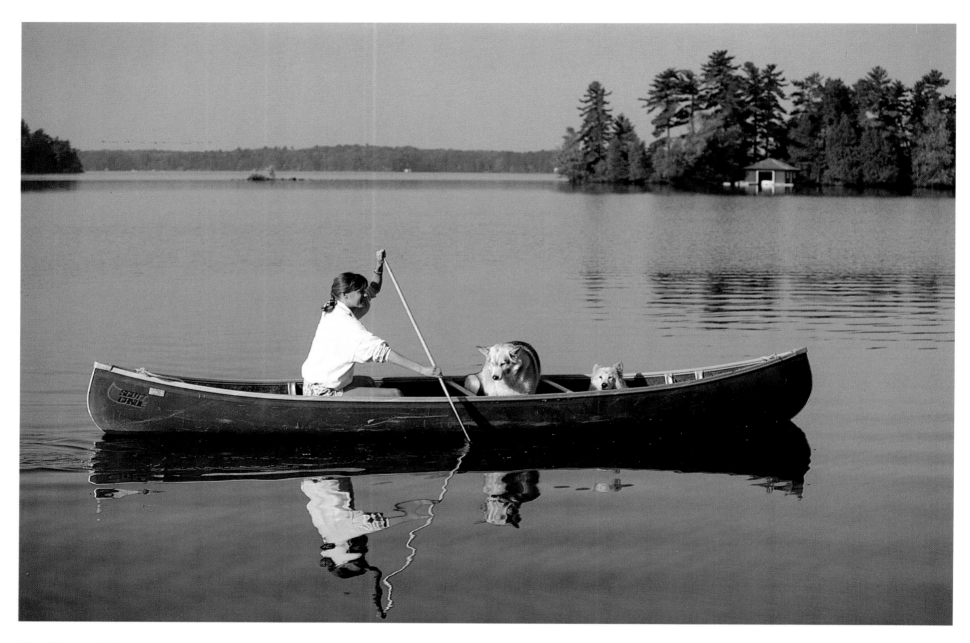

The 'Dog Paddle'

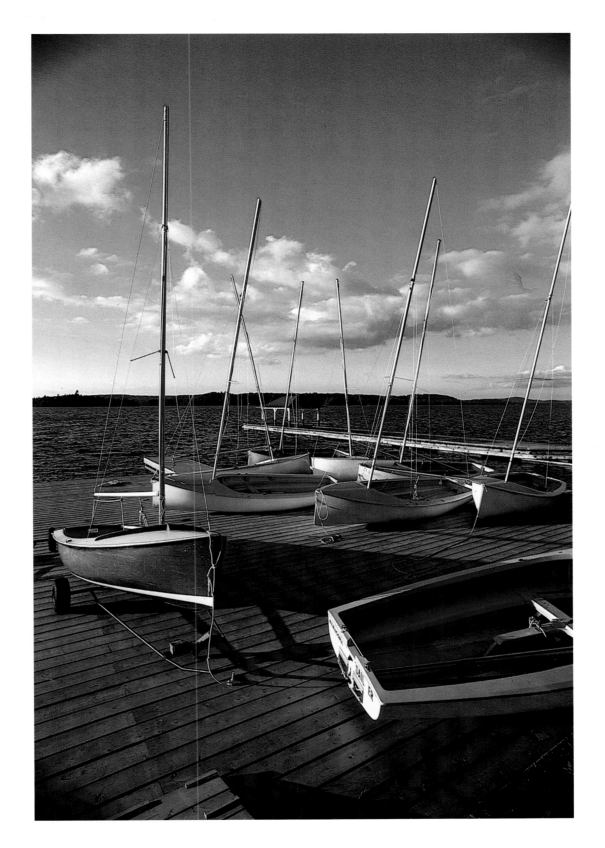

Norway Point, Lake of Bays

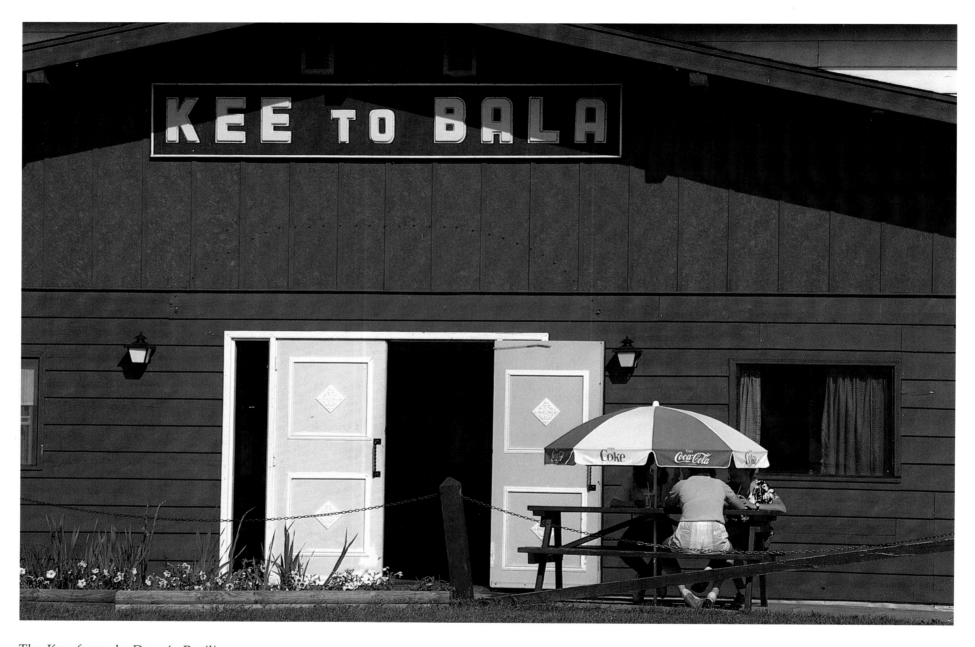

The Kee, formerly Dunn's Pavilion

THE BIG WHITE PAVILION

July 27, 1987. It's just past noon on a hot cloudless day. She walks across the lawn in front of the Kee to Bala. The grass is yellow, not a shade tree in sight, a redwood picnic table with a lopsided Coca Cola umbrella stands outside the entrance. It's not the way she remembered it. Back in the fifties it was Dunn's, the Big White Pavilion where all Muskoka danced. Back then, there were shade trees and green lawns, flickering coloured lights and a splashing fountain, a full moon above the outdoor deck and romantic big band music floating through the open front doors and across the moonlit bay. Wasn't there?

She pushes open the wooden door and enters the pokey foyer plastered in posters. It smells of stale beer and the only sound is a broom being pushed across the floor by a young boy with long muddy-blonde hair and a gold earring.

Leaving the dim interior she goes out the back door into the sunlight. The deck is still there, rebuilt but still commanding the same view of Bala Bay. At its peak Dunn's attracted about 1,200 people on a Saturday night, and one legendary night 2,000 people came to hear Louis Armstrong. They came from all over the district, some by car, some in hotel launches like the *Wiggy III* from Wigwassan Lodge, way up in Lake Rosseau, and some just anchored in the bay to listen to "Begin the Beguine" wafting across the water. Duke Ellington played here. So did Stan Kenton, Les Brown, Tommy and Jimmy Dorsey, Woody Herman and Guy Lombardo. Gerry Dunn ran this successful dance pavilion for 30 years without a liquor licence.

Now the Big White Pavilion is known as "Rock Heaven." But the night the visitor remembers was in August of 1956. She was 14 and bored to death at the cottage. So was her girlfriend. Her father, in order to appease these pubescent girls, offered to take them to Dunn's on Saturday night.

"Okay, okay. It might be fun. I mean, it's not like having a date, going with your *parents* to Dunn's. But okay."

Preparations begin and a problem arises. The girlfriend has a crinoline. *She* doesn't, so *she* can't go. That's it. She can't go.

Her father, by now driven to desperation, decides to "make" a crinoline — from the screen on the back door. She's not thrilled. It's not comfortable. But then, none of them are. And besides, Dad will kill her if she doesn't go now.

The big night. Mom, Dad and the girls drive to Bala and enter the softly lit pavilion along with other elaborately dressed folk wearing big smiles. Many of the men are hiding flasks beneath their sports jackets. They find a table on the balcony and almost before she has her screen crinoline properly arranged on her chair some squirrelly guy asks her girlfriend to dance. She wants to die. Now she's sitting with her *parents* and she can see her girlfriend laughing and dancing, ignoring her totally. By now her screen crinoline has made crisscrosses all over the backs of her thighs, so just to relieve the discomfort she accepts her dad's offer to dance. After a few controlled swoops about the floor she's actually beginning to enjoy herself, when suddenly, without warning, her screen crinoline comes

Summer romance

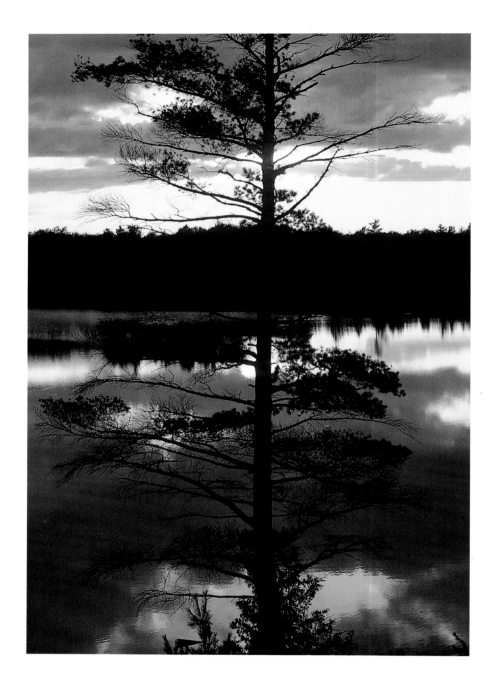

End of day, Bala

undone and falls to the ground in the middle of the dance floor. Mortification! As people laugh and point she steps over the screen, runs outside to the car, locks herself inside and refuses to ever *ever* go near Dunn's Pavilion again.

Today, many years have passed and she is back for the first time. The young man with the muddy-blonde hair taps her on the shoulder.

"Can I help you ma'am?"

"No thanks. I came here once when I was a young girl and I've just been looking around."

"I understand it was quite a place back then," he comments.

"Yes," she says, "I guess it was."

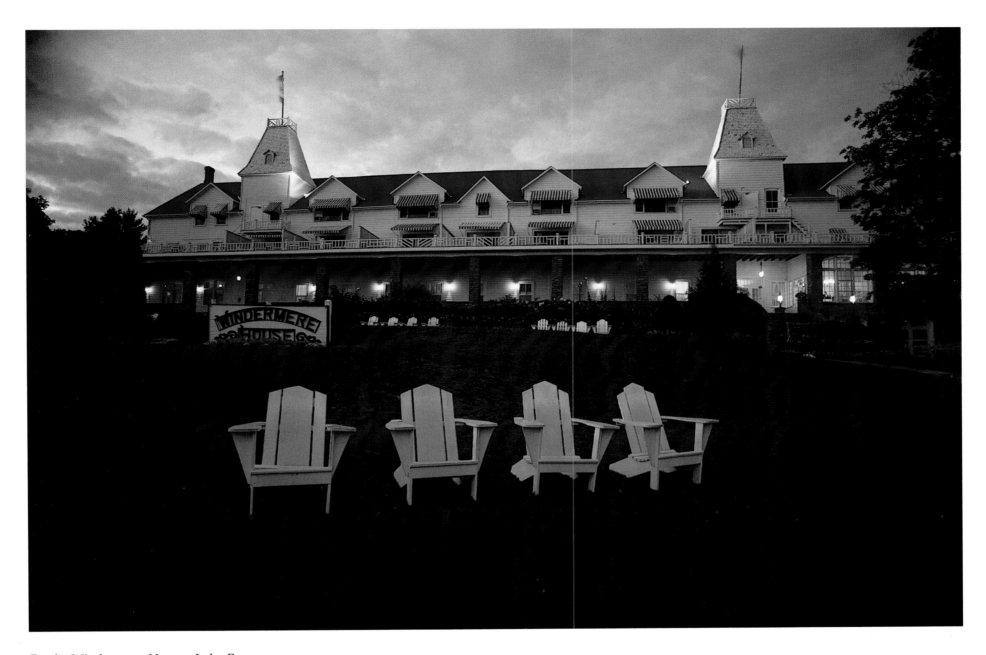

Dusk, Windermere House, Lake Rosseau

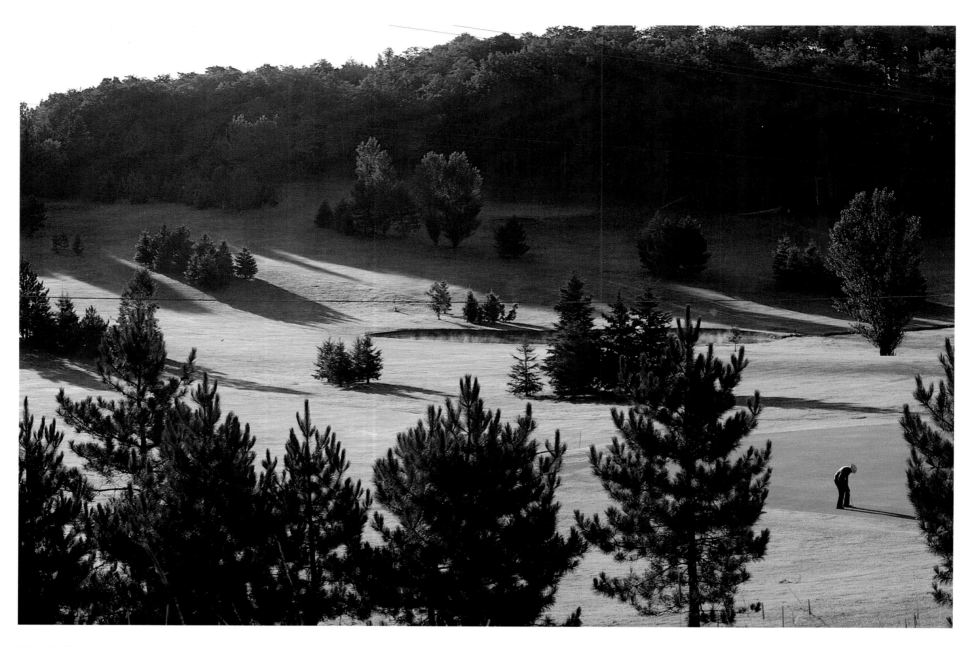

The Golf Course at Deerhurst Inn

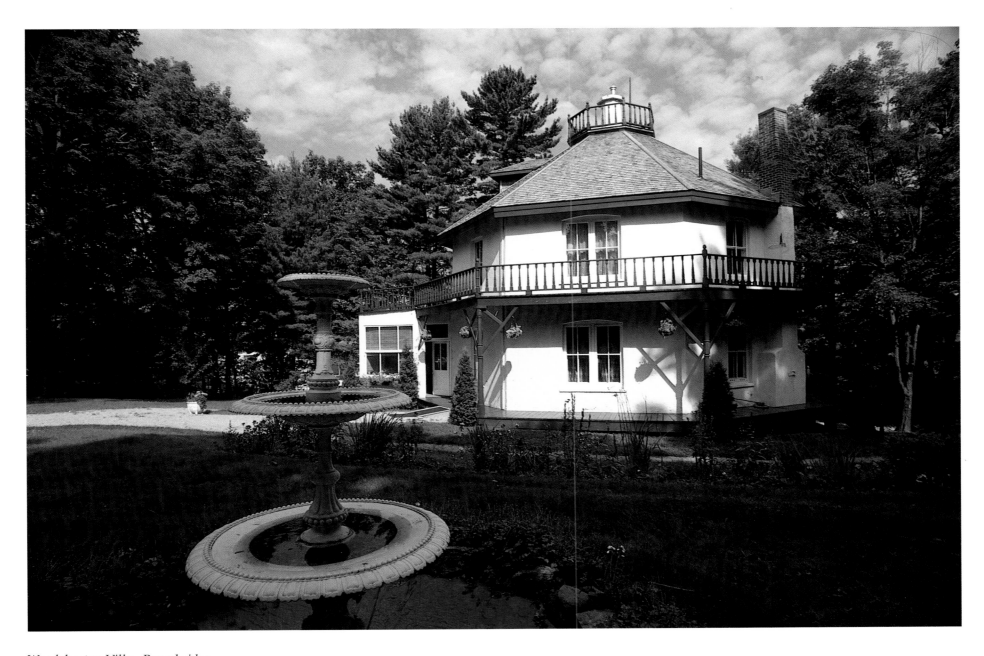

Woodchester Villa, Bracebridge

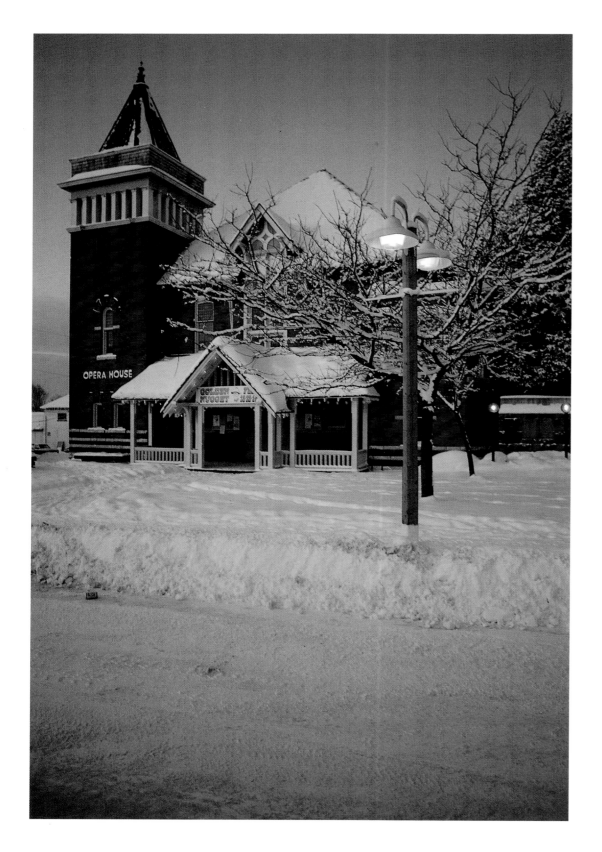

The Opera House, Gravenhurst

GRAVENHURST'S GRAND OLD OPERA HOUSE

March 12, 1901. It's opening night at the newly built Opera House in Gravenhurst. The townspeople show up in their finery, paying 25, 35 or 50 cents a seat to see a revue called *The Days of the Year*, which features group singsongs, dances by the "Welsh Ladies" and a performance by the Town Band. Many in the audience have come out of curiosity to see how the exorbitant amount of $10,000 has been spent on this building. The construction of this new Town Hall and Opera House has been much discussed ever since 1887, when the old Town Hall burnt down in a fire that almost destroyed the entire town. Thirteen years passed before the Town Council approved the new building and selected architect J. Francis Brown of Toronto as its designer. Tonight, it's quite a showplace. The wood-beamed ceiling, stained-glass windows, twin brass chandeliers (that cost $50 each) and impressive acoustics meet with most everyone's approval.

A summer night, 86 years later. It's opening night of Neil Simon's *Brighton Beach Memoirs* at the Gravenhurst Opera House. A group of suntanned, casually dressed cottagers and tourists from nearby lodges gather around the brick courtyard in front of the theatre. As the bell rings the crowd files into the old building, up the creaky wooden staircase, past the amber-coloured leaded windows and into the cavernous auditorium with its vaulted wood-beamed ceiling. They settle into the original wooden chairs, now made somewhat more comfortable by a thin padded cushion, and await another production of the Muskoka Festival.

Both the Opera House, which has been called the loveliest of Canada's small summer theatres, and the Muskoka Festival, which presents live professional theatre in Gravenhurst and Port Carling from the end of June to Labour Day, seem buoyantly successful on this soft summer evening. But it hasn't always been so. Theatre in Muskoka has had its "dark" days and the Opera House itself very nearly met with the demolition ball back in 1965.

At that time a plan to tear down the building and replace it with a shopping mall caused an uproar among those who wanted to save the old building. Gordon Sloan, a long-time restaurateur, began a support committee called the Opera House Commission. When a local referendum was held, the people of Gravenhurst, who numbered 3,000 at the time, voted to keep the Opera House, and later raised a $100,000 debenture to pay for renovations.

By 1972 the grand old lady had been spruced up and boasted a 15-foot addition at the back, which housed dressing rooms, a kitchen and a bar. That same year the Muskoka Summer Theatre was born, reviving a tradition that had begun with the John Holden Players in 1934 and then been carried on by the Straw Hat Players, started by Donald and Murray Davis in 1948. Home base for the Holden Players was in Bala, while the Straw Hat group performed in Port Carling, Huntsville and Gravenhurst. Donald Davis recalls that a season of summer stock in New York was so intoxicating that he and his brother decided to try it in Canada. They chose Muskoka because their family cottage was (and still is) here.

Thus, theatre in Muskoka has long and loyal roots. But many cottagers have memories of days when it wasn't so

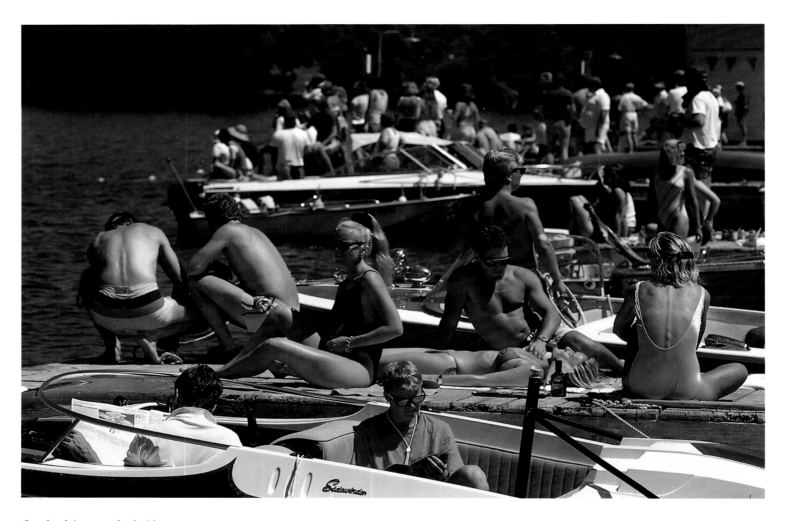

Sunbathing at dockside

easy to be supportive: sweltering summer nights spent fanning oneself with a program in the Opera House (air-conditioning wasn't installed until 1976); ducking from a bat that swooped through the Port Carling Memorial Hall during a dramatic thriller scene (and the actors carrying on as if nothing was happening); being among a scant 17 people in the 340-seat Opera House during Michael Ayoub's opening night of his first season with Muskoka Summer Theatre in 1973.

But there were magic moments too: seeing Donald Sutherland play Bo Dekker in *Bus Stop* in 1960 (before that he worked with the company as a set decorator); seeing legendary actors like Kate Reid, George Sperdakos, Sean

McCann, Barbara Hamilton, Charmion King, Araby Lockhart and William Hutt, among others; watching the Muskoka Festival evolve from that opening night with only 17 in the audience to a thriving summer theatre playing to full houses and committed to producing new Canadian musicals and dramas; seeing something succeed in Muskoka.

The crowds are filing out of the theatre now. It's dark as they make their way to their cars or pile into buses to return to their hotels. The production was a crowd-pleaser, and even though it lasted almost three hours, and the wooden seats built in 1901 aren't very comfortable, most of the suntanned crowd seem jovial, willing participants in the combined success of two grand old Muskoka institutions.

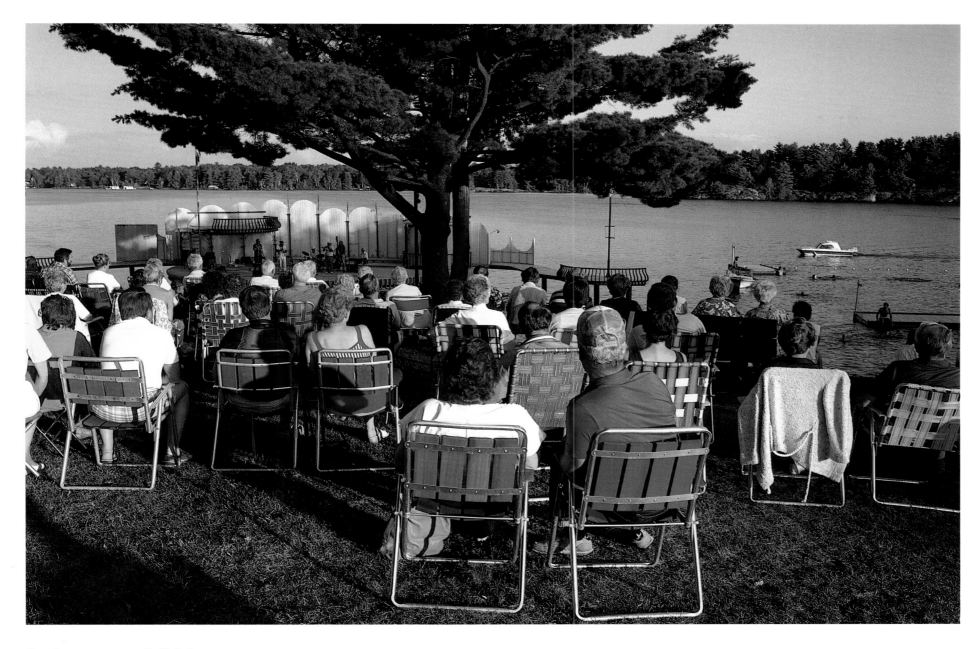

Sunday concert at Gull Lake

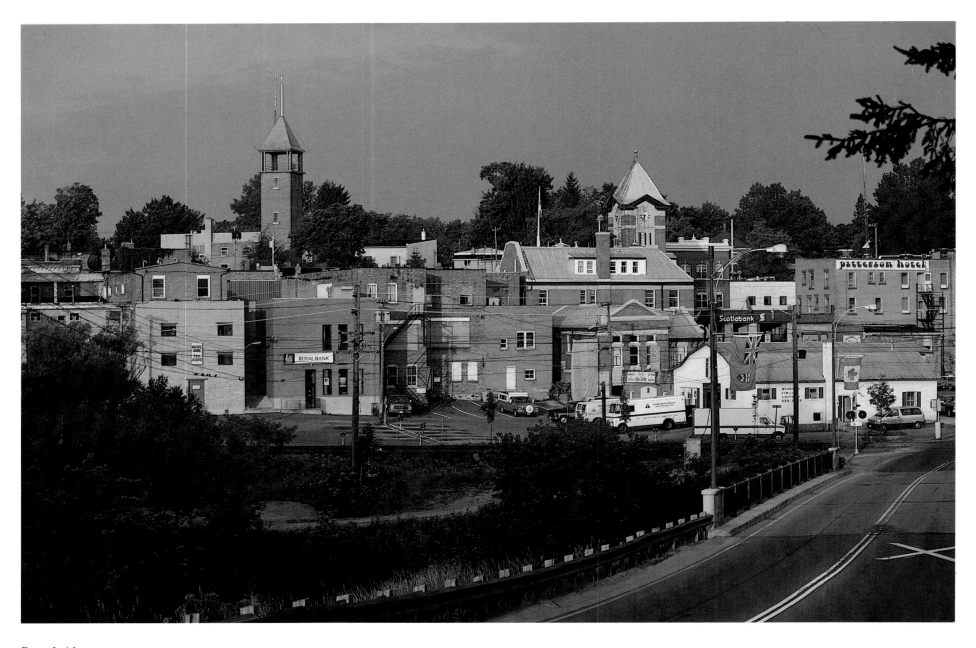

Bracebridge

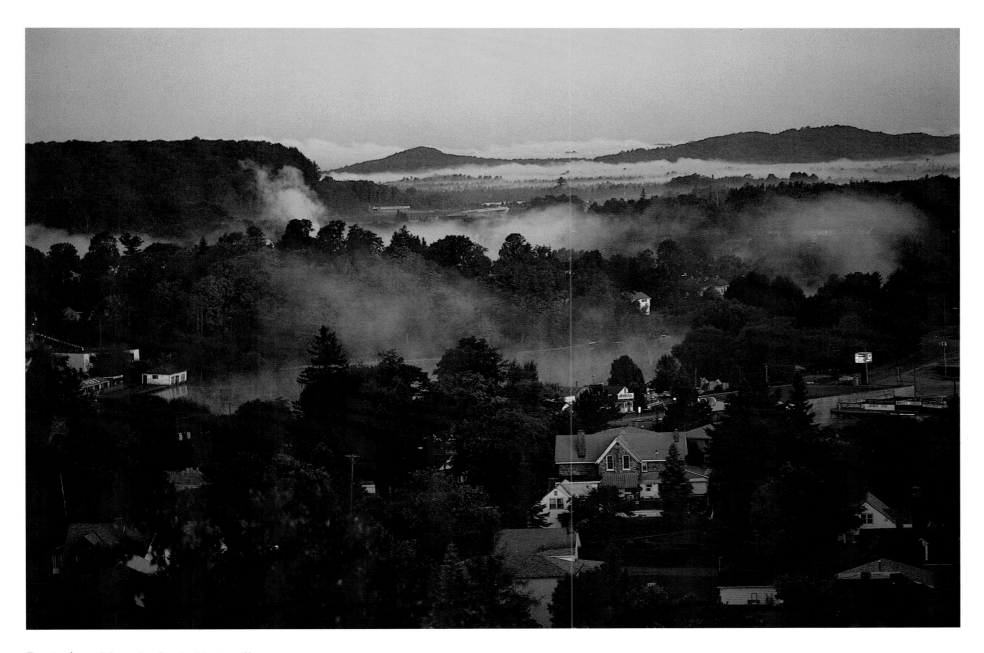

Dawn from Lions Lookout, Huntsville

Frozen cranberries, Gibson Reserve

MOHAWK INDIANS

August 29, 1987. Behind the counter in his Port Carling craft shop Frank Roads writes laboriously, noting the purchase of two leather bracelets, one toy birchbark canoe, and one woven-grass sewing basket. Each item is pencilled in a tattered hardcover ledger. His face is handsomely aged, outlined by the strong cheekbones of his Iroquois Indian heritage.

"My granddaughter made the bracelets," he says proudly, placing the articles carefully in a brown paper bag.

The tiny shingled store owned by Frank and his wife, Phoebe, is at the edge of the Indian River in Port Carling, the sole remnant of what was once a busy community of Indian families that came here every summer from reserves as far away as Quebec. The town's name, "Obogawanung," was soon changed to "Indian Village" and every summer the families lived here. The men spent their days fishing and evenings carving snowshoes and tomahawks. The women made sweet-grass and porcupine-quill baskets and deerskin moccasins studded with intricate beadwork. By day they paddled about the lakes selling their handiwork to the cottagers, many of whom can still remember the taste of their freshly caught fish, which was kept cool under a bed of green ferns in the bottom of the canoe. Some of the tribe stayed in the village to sell their crafts. There, they unlatched the wooden shutters on their cabin fronts, converting them to tables for displaying their wares. Then at night they folded them up to form a wall of the house.

It's easy to forget that this was once Indian territory. The only remaining land belonging to the Indians in Muskoka is the Gibson reserve, a vast tract of land which, from the main road running between Highway 69 and Bala, seems virtually deserted. The ancestors of these Mohawks of the Gibson reserve were a band of Quebec Iroquois who in the eighteenth century settled near the village and seminary of Oka, Quebec, where the monks later made their famous cheese. When Protestant missionaries arrived in the early 1870s, they began converting the Iroquois from Roman Catholicism and before long most of the Indian population had become Methodists, built a chapel on the grounds and encouraged a Methodist minister to join them. After their chapel was smashed to pieces by outraged French Canadians, the situation became increasingly hostile, until the Quebec Provincial Police arrived one night in June 1877 to arrest the Indians for trespassing. Later that same night, a huge fire broke out in Oka and destroyed many of the buildings in the village, including the Catholic church. Four years later, in 1881, the Iroquois were finally moved out of Oka, and after being offered a choice of locations, they chose a reserve in Gibson Township in the District of Muskoka.

Today the band consists of about 250 members, but few of them still live on the reserve. Frank and Phoebe Roads are two who carry on the traditions of their Indian heritage. They make nearly everything they sell in their shop. Frank makes baskets out of sweet grass and Phoebe sews deerskin moccasins, decorating them with skilfully designed beaded patterns, many made to order for loyal summer customers. After summer they close up their Indian River shop and return to their home on the reserve, where they continue to

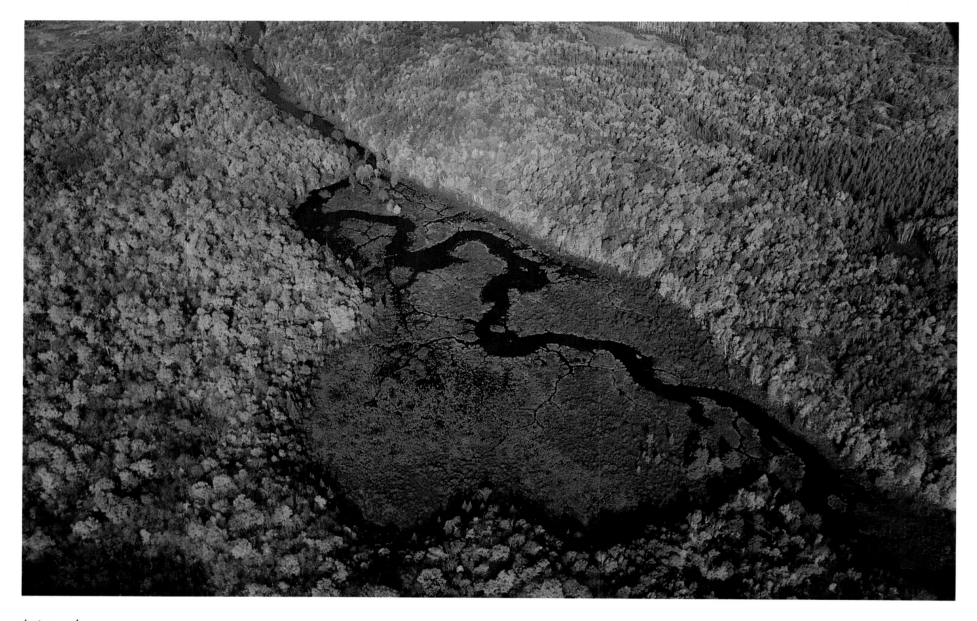

Autumn hues

work, preparing a supply of crafts for the coming summer. They worry that this craftsmanship may die with them. Few of the young people are interested in carrying on the tradition, even though the Roads' granddaughter does make woven leather bracelets.

As Frank adds up the numbers in his ledger he talks guardedly about his life, his ancestors, the bloody battles that brought them to Muskoka, the hardships of the journey from Quebec, the epidemic of smallpox that nearly decimated the Mohawk band, and the struggle to keep their customs alive. His hands are strong and calloused from years of labour. His body, still muscular, has the bearing of a survivor. And on his head is a black baseball cap with yellow letters claiming: "Paradise Island: It's Better in the Bahamas."

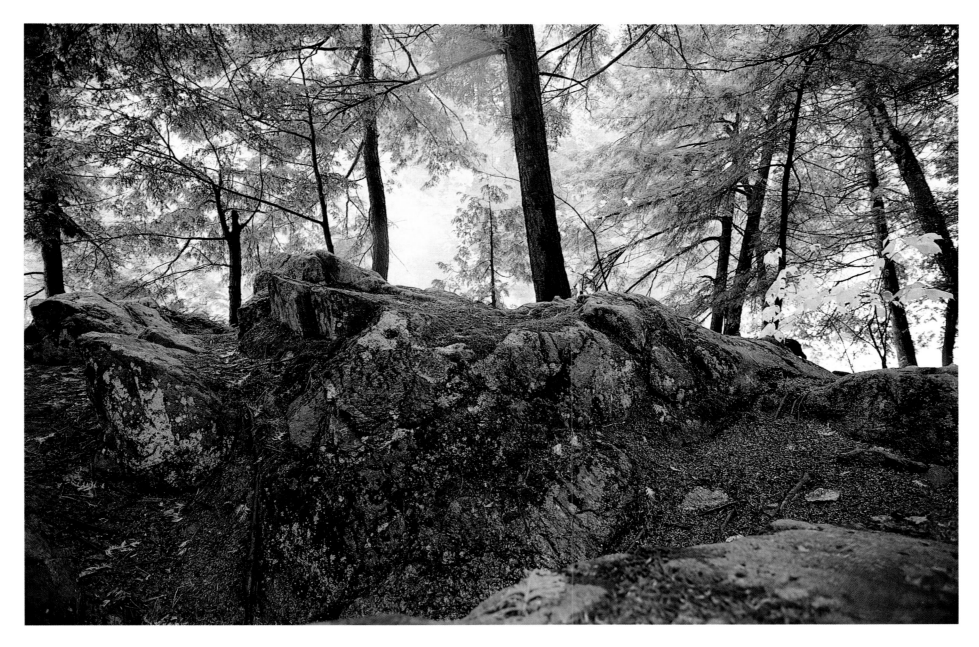

The forest floor

Cavalcade of colour

THANKSGIVING

October belongs to the trees. Across the lake the coloured leaves seem like a splash of brilliant paint between the baby-blue sky and the deep-blue lake. Scarlet maple, golden birch, amber-coloured oak — all part of the colourful tapestry, "The Cavalcade of Colour," that brings busloads of tourists to Muskoka every autumn.

For cottagers October means Thanksgiving too, the last long weekend at the lake before winter, a chance for long walks in the woods, visits with summer friends, collecting coloured leaves for the table centrepiece, and endless lists of chores.

"The leaves are past their peak," huffs an elderly aunt, a self-proclaimed expert on fall foliage who hasn't missed a Thanksgiving in Muskoka since 1923, "just look at the forest floor."

True, a thick carpet of furled leaves lies there disturbed only by the chipmunks and squirrels scurrying to hiding places, cheeks bulging with acorns. Above them shafts of sunlight pierce through the newly bare trees and out on the lake a lazy swirl of morning mist hovers over the surface. The tangy incense of wood-burning fires fills the air, mingling with the comforting scent of roasting turkey wafting from cottage kitchens all along the shore.

This is the traditional feast time, a time for gathering of the clans, fireside stories, pumpkin pies and wishbone wishes. And the same scenario unfolds year after year, because of all cottage rituals, the traditions of Thanksgiving are perhaps the most cherished and the most immutable.

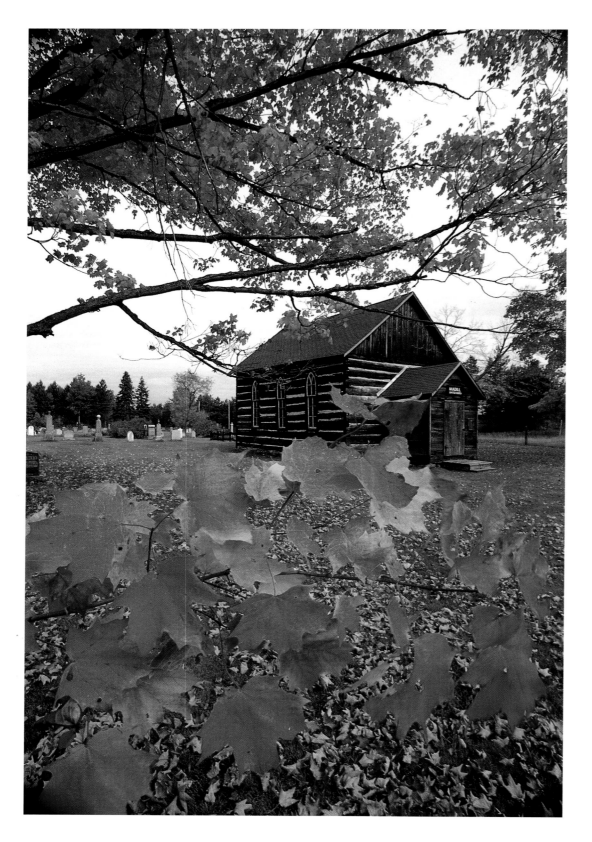

Madill Church, south of Huntsville

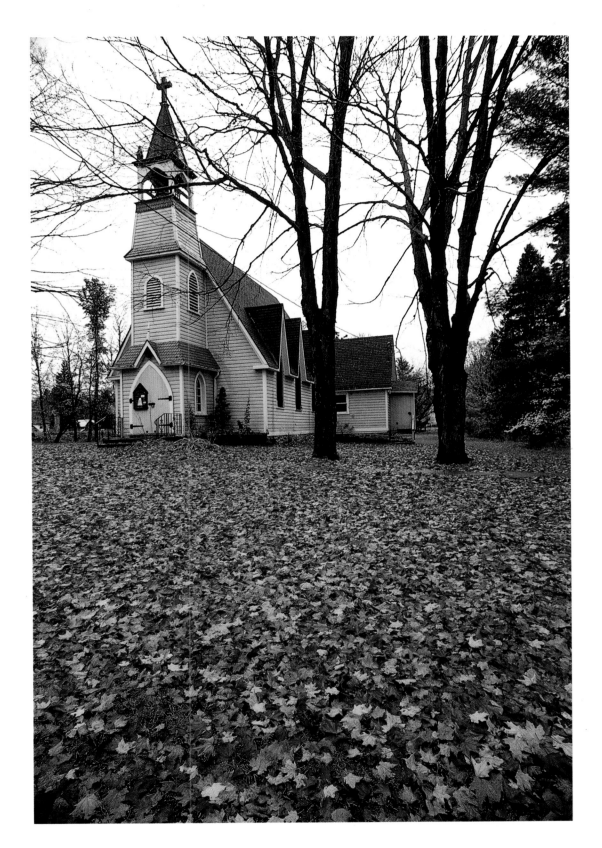

Rosseau Anglican Church

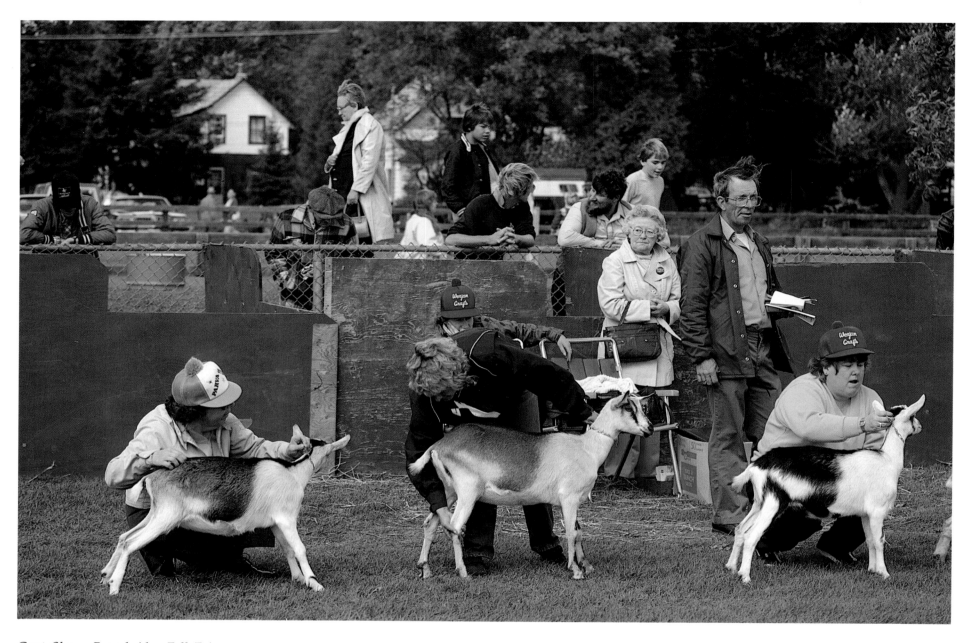

Goat Show, Bracebridge Fall Fair

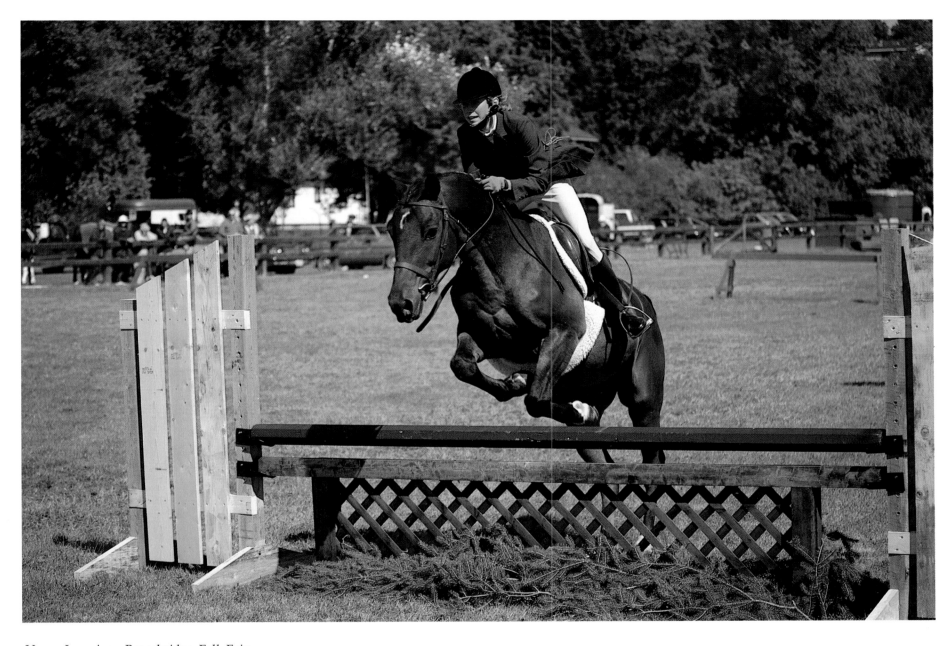

Horse Jumping, Bracebridge Fall Fair

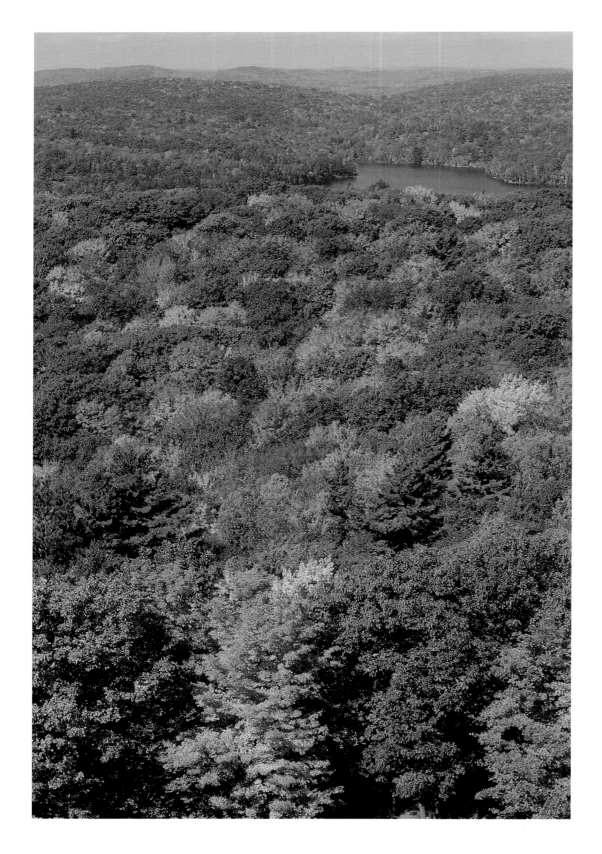

View from the Fire Tower at Dorset

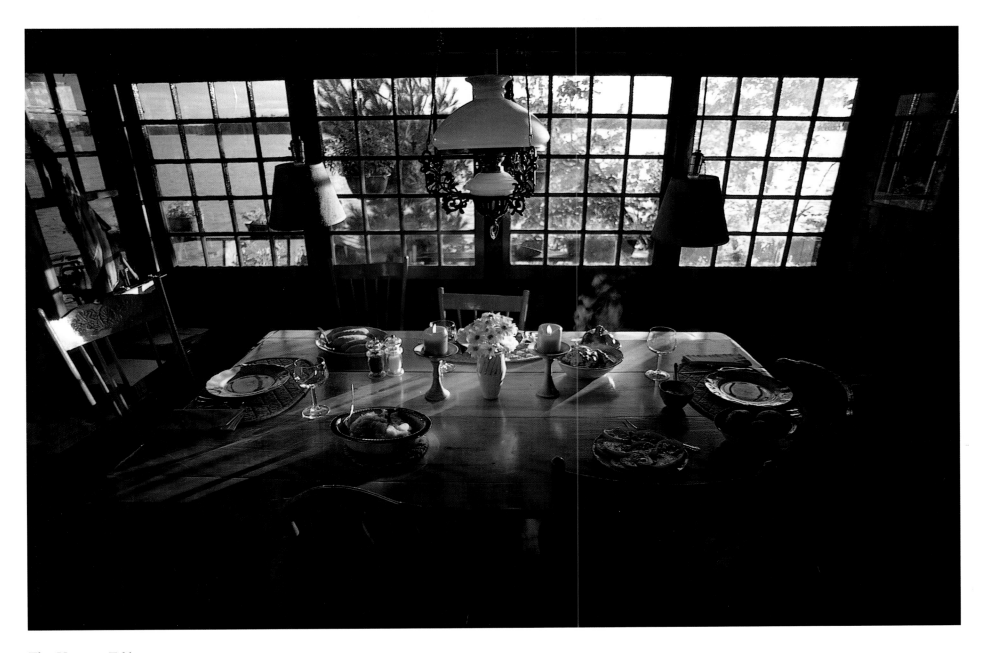

The Harvest Table

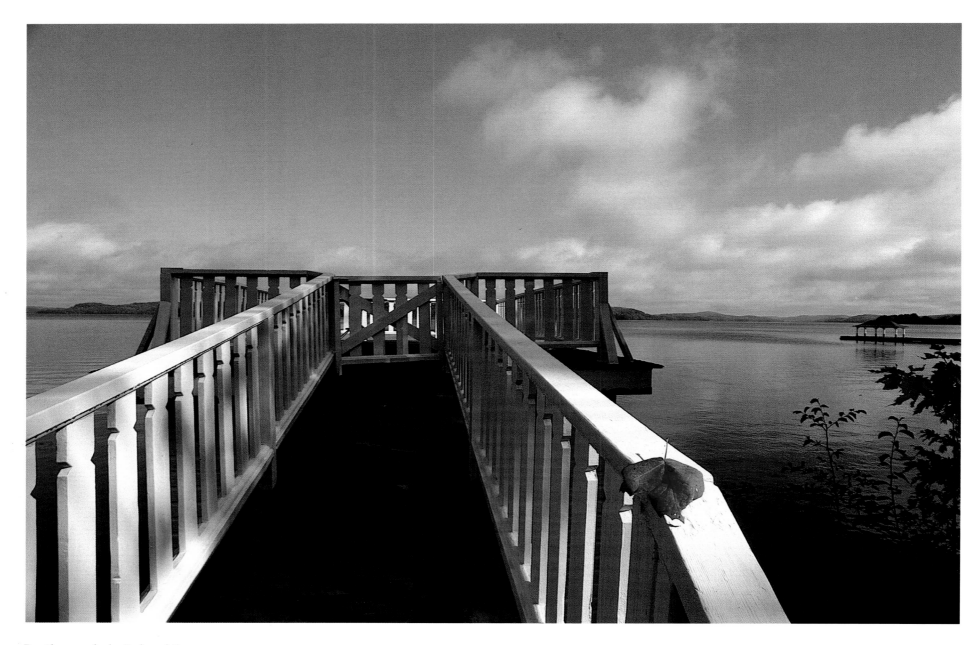

Boathouse deck, Lake of Bays

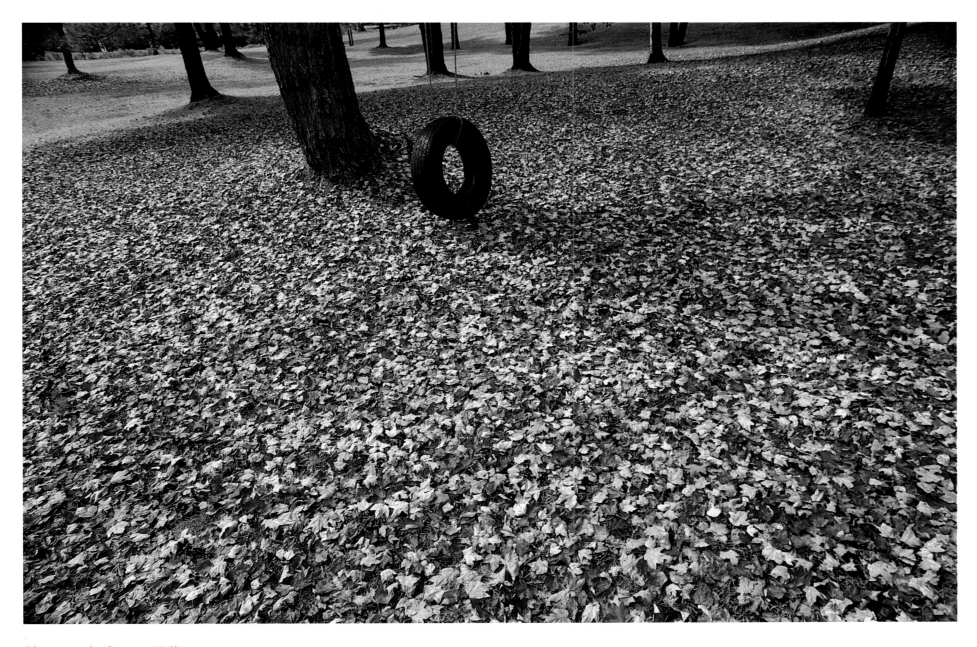

Playground, Coopers Falls

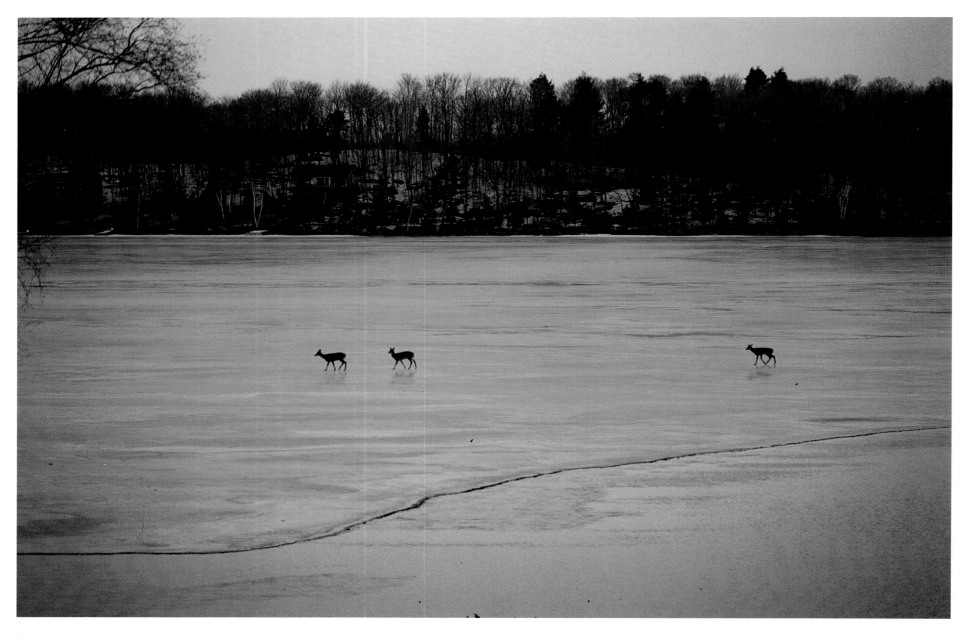

Crossing the ice at Port Sandfield

THE DEER

It's early morning on a country road. The sun, newly risen, casts a rosy glow across the sky and dapples the lake with pink sunbeams. The meadow is coated with dew and the unpaved road through the woods feels cool and damp beneath bare feet. Four-year-old Jonathan, an early riser who's along for the walk so that others at the cottage can sleep in, wants to see some animals in the woods.

"Won't they be getting up for breakfast soon?" he asks, peering behind a juniper bush, hoping to find some kind of furry creature. "Sometimes, if we're very quiet, we see deer along this road," she answers, hoping the deer will co-operate today.

As the walk progresses, the only animal discoveries are a squished frog, which has been run over by a car, and a persistent deer fly, which buzzes overhead despite Jonathan's shrieks of "Go Away Fly!" Turning to go home they pass through the meadow, now basking in new light as the sun creeps higher in the sky. Jonathan stops suddenly.

"Shhhh," he whispers, holding a finger to his lips and pointing with his other hand to a hillock across the meadow.

There, with their alert heads raised high, are three white-tailed deer, a mother and her twin fawns. The babies, probably only a few months old but strong and steady on their long limbs, stay close to mother, and all three stare with enormous brown eyes. Jonathan stands as still as a palace guard. And the deer, seemingly as interested in him, don't move either. Then something rustles in the long grass and with a flash of their white rumps they bound off into the woods.

Back in the days when Muskoka was first attracting attention as a beautiful lake region, among the first white men to venture here were hunters. Lured by the multitude of deer, they started numerous hunt clubs in the early 1900s. Old photographs show them standing proudly beside their felled deer, guns slung across their shoulders. Today, the survival of these magnificent animals in a healthy state still depends on hunting. With a breeding pattern that has every doe producing two and sometimes three or four fawns every spring, it doesn't take long for the population to grow out of control. And starving deer can do immense damage in the winter, when they demolish browse species and valuable trees that cannot be regenerated.

In the last five years the deer population in Muskoka has doubled, mainly because of mild winters and a decreasing wolf population. One perturbed cottager attending the annual meeting of the Muskoka Lakes Association claimed that the deer had virtually destroyed his lakefront property, chewing their way through every bush and tree in sight. The solution, it seems, is to hope for a long, cold winter, to plant trees that deer don't like, and to increase the number of permits given out for the November hunting season.

That night, as he was being tucked into bed, Jonathan was still talking about the deer.

"When I come back to the cottage next summer, will the mother and her two babies still be in the meadow?" he asked.

"I hope so," she replied.

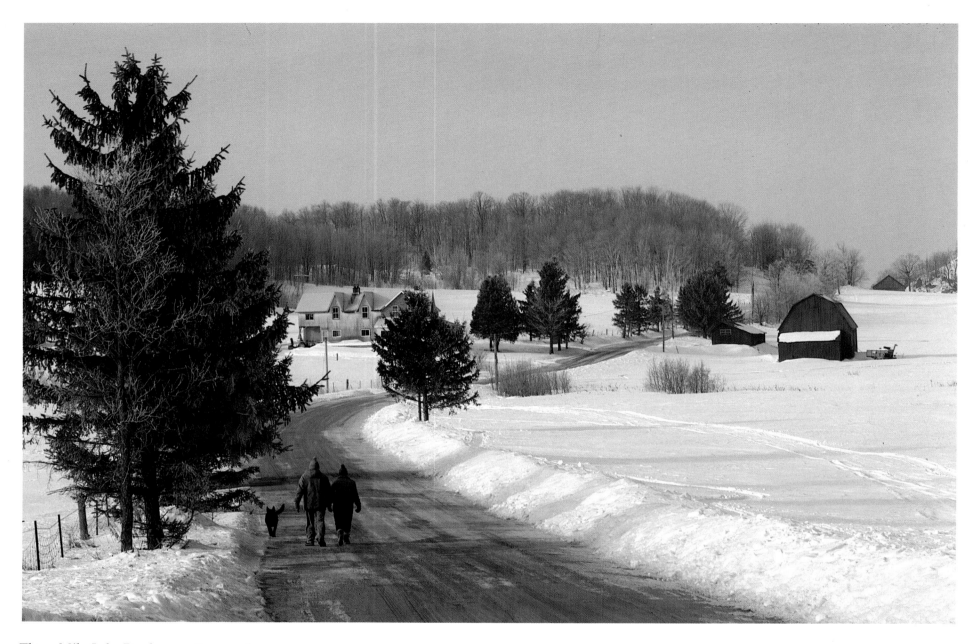

Three Mile Lake Road, near Raymond

WINTER

Beneath a cloudless sky the land is smothered in snow. Just a week ago the lake froze, rings of ice pushing out from the shore, stilling the waves. Now sheets of white stretch to the far shore, blanketing the black water. The woods are just as still, muffled by gentle drifts of snow, icy armor coating the trees. It's winter. Muskoka's other season has begun.

It used to be a well-kept secret, the silent season known to permanent Muskoka folk and only a handful of cottagers who loved their summer playground when the shoreline was snow-clad and deserted, when the only movement was a bounding deer heading across the lake to a neighbour's island.

Before the days of electric heat, space-age insulation and cables in the water line, there were people who didn't mind the hardships of winter cottaging. Part of the adventure was hauling a toboggan-load of groceries down the unplowed road, chopping a water hole through a foot of ice, wearing parkas and mittens inside until the wood stove churned out enough heat and boiled that first welcome kettle of water, then, after digging firewood out from under a pile of snow, falling sound asleep snuggled in flannelette.

But now, with winter carnivals, year-round resorts, snowmobile clubs and winterized cottages, Muskoka is shedding its snowbound image and becoming a winter playground as well. Snowmobile tracks crisscross the landscape, cross-country skiers stride along the shore, downhill skiers flock to the area's highest peaks, and for one raucous weekend in February the towns of Gravenhurst, Bracebridge and Huntsville close off their main streets, dump heaps of snow on the roadside for snow sculpting, and celebrate Winter Carnival.

Still, with all this activity, it's the solitude at the cottage that makes winter so special. The closeness of the stars in the winter sky, the squeak of clean snow beneath furry boots, the tingle of crisp air — and the utter silence, broken only by the chirp of a chickadee and the distant rumble of ice forming somewhere out on the lake.

West of Dorset, Lake of Bays

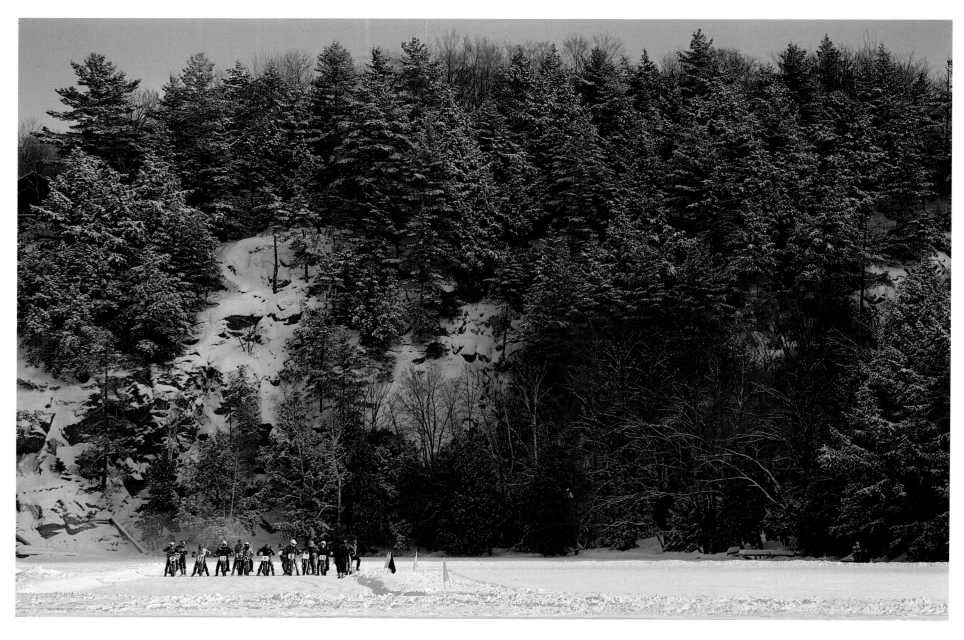

Motorcycle Race, Skeleton Lake

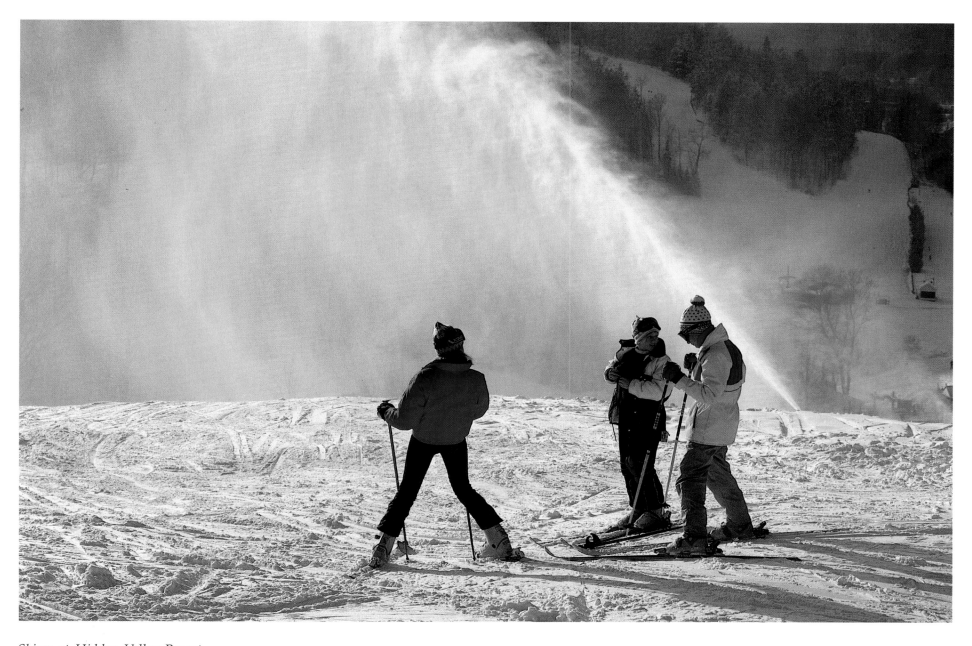

Skiers at Hidden Valley Resort

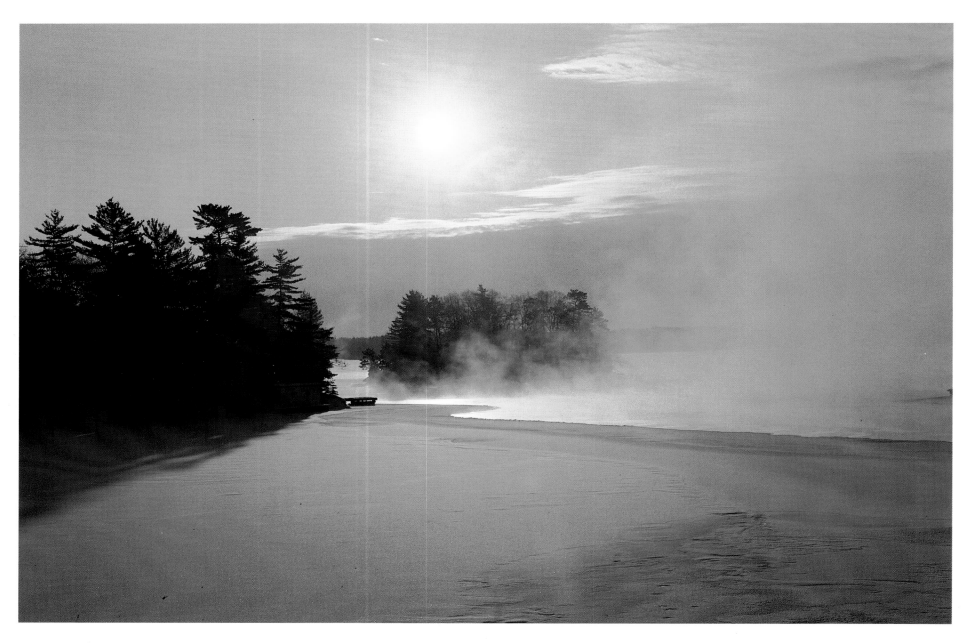

Sunrise, Bala Bay

Along Highway 60 east of Huntsville

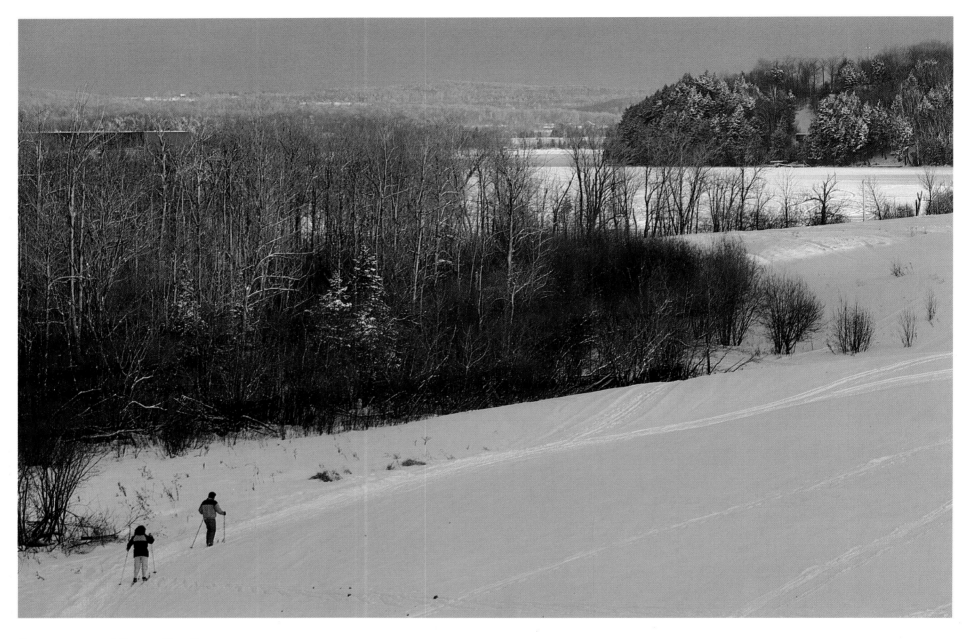

Cross-country skiing at Deerhurst

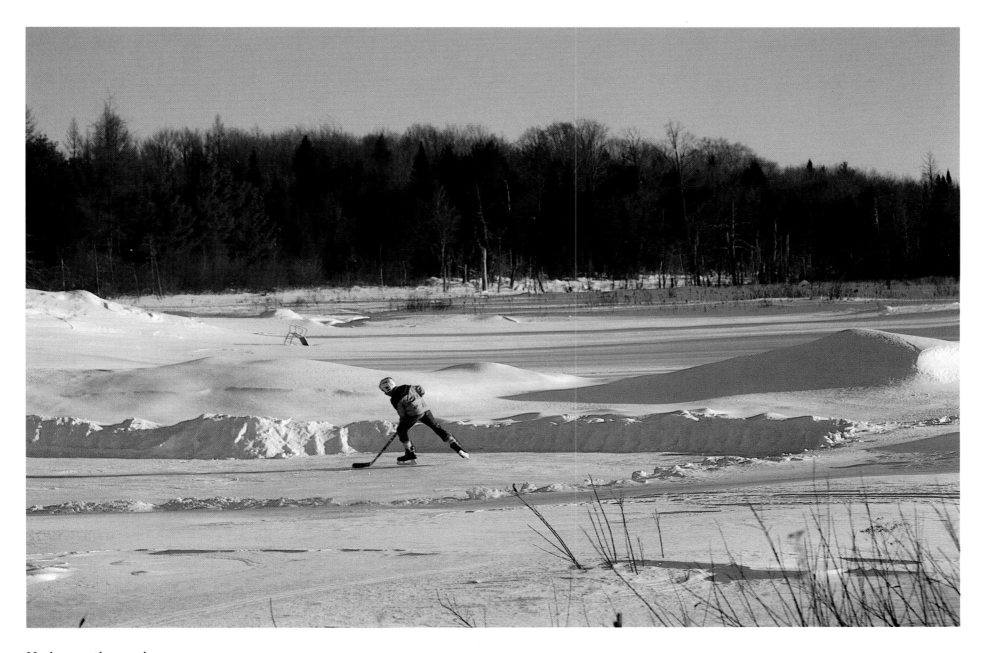

Hockey on the pond

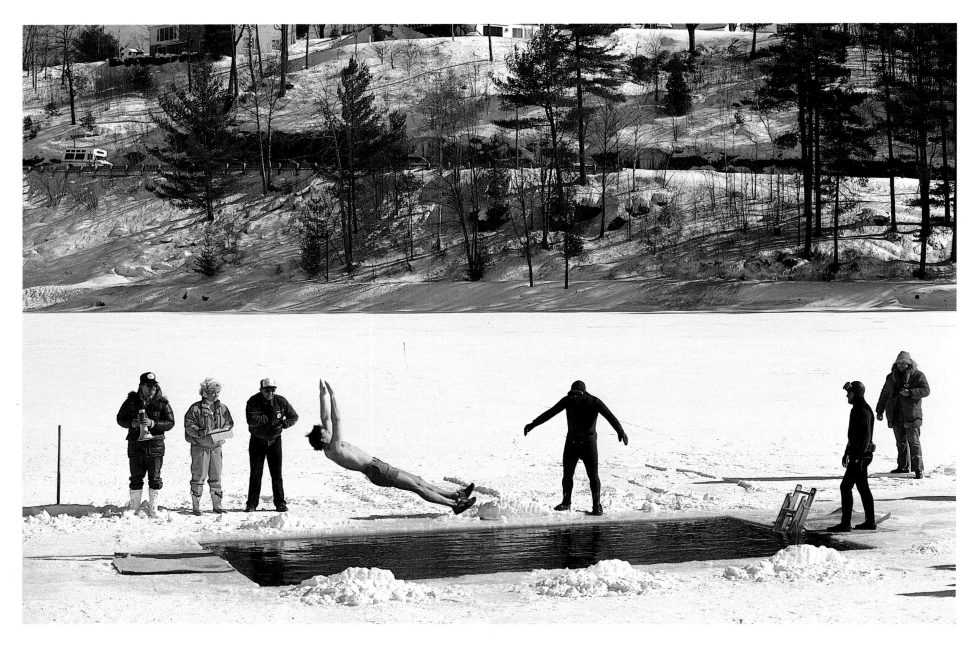

Polar Bear Dip, Winter Carnival at Bracebridge

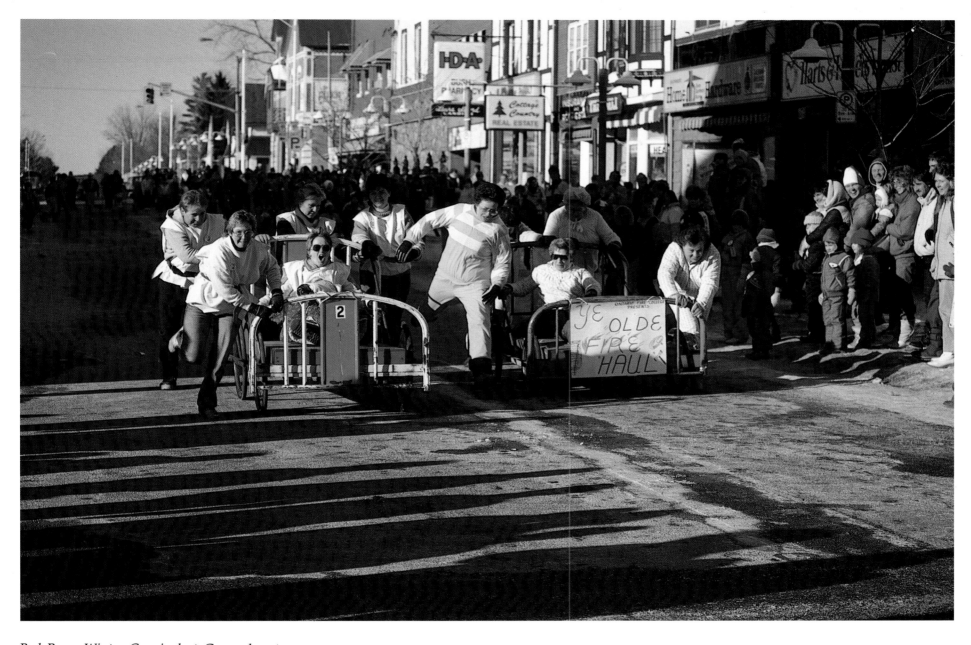

Bed Race, Winter Carnival at Gravenhurst

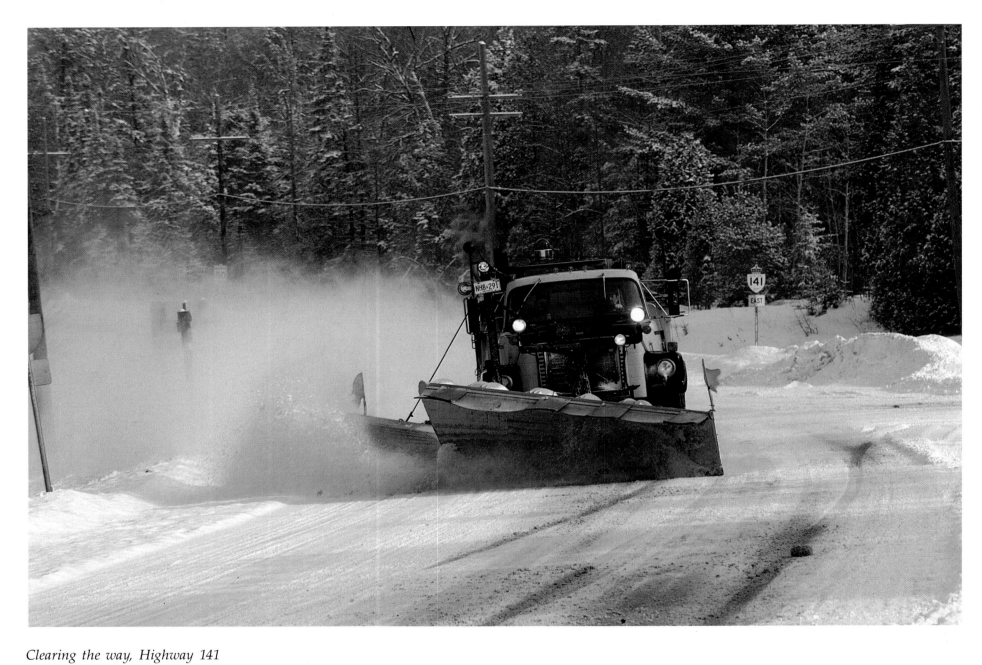

Clearing the way, Highway 141

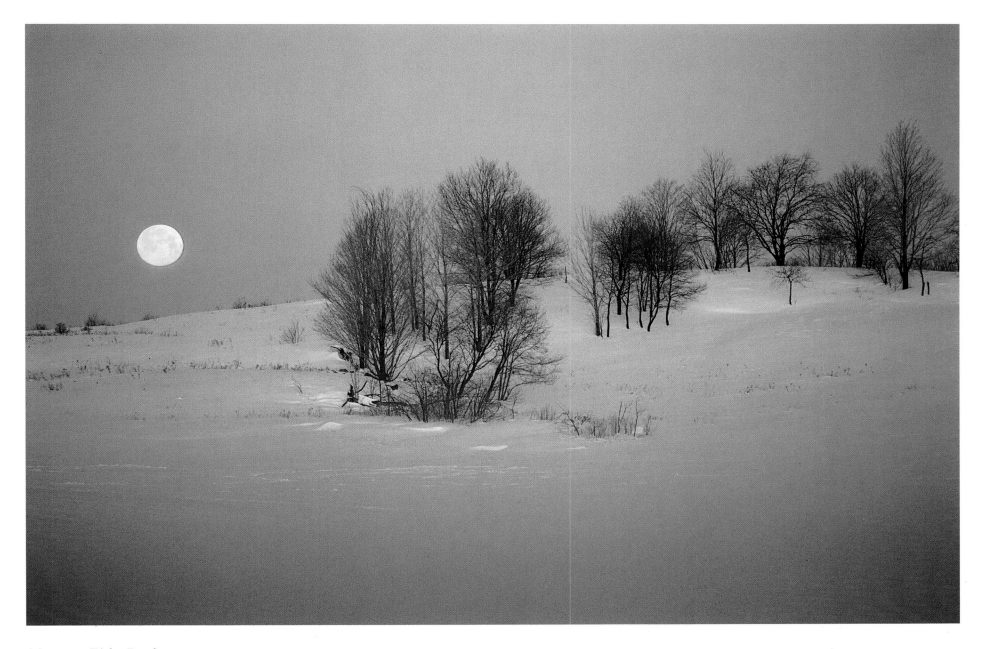

Moonset, Ziska Road

Muskoka Pioneer Village, Huntsville

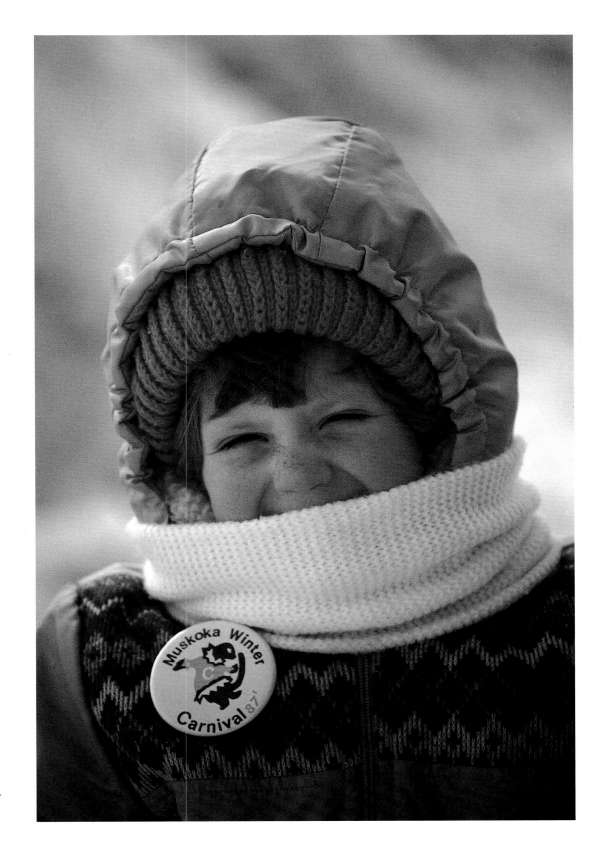

Muskoka Winter Carnival, Bracebridge

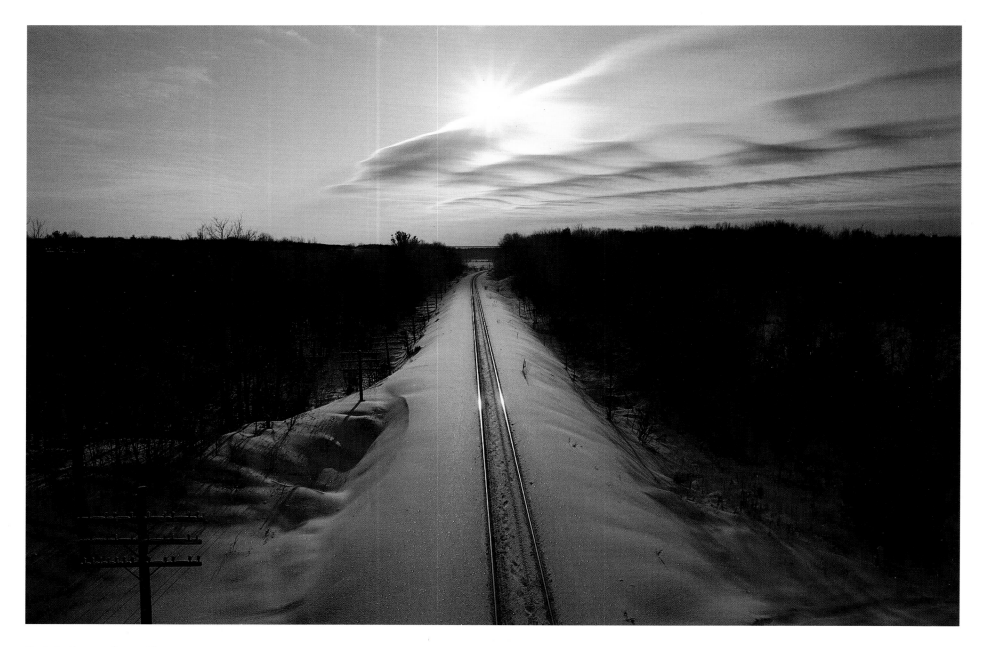

Foote's Bay railway line